ROYAL LEAMINGTON SPA

THROUGH TIME

Jacqueline Cameron

AMBERLEY PUBLISHING

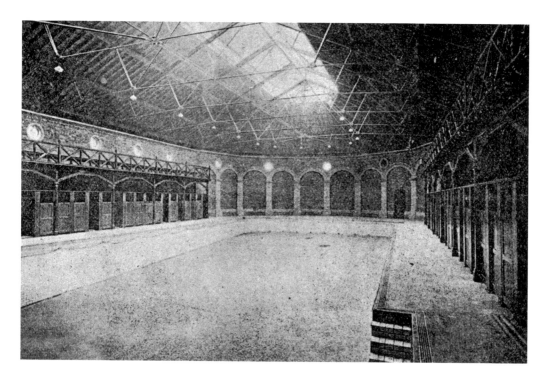

Swimming Baths

Opened 1890. A stone tablet on the east end of the bath states 'Opened by J Fell, Mayor in 1890'.
He was to take a second term in office as mayor from 1889-1890. This tablet was removed c. 1960.
In the ground floor vending area there is, on the wall, another tablet which reads: 'This plaque was
unveiled on 27 October 1956 by the Prime Minister the R. Hon. Anthony Eden K.G. M.C.M.P. to
commemorate the reconstruction of the swimming bath. Originally opened by John Fell, Mayor, L.
G. Clayton, Chairman Spa Committee and E. A. Baxter, mayor.'

Dedicated to Graham Edwards and his wife
for the lovely memories of my last long service dinner.

First published 2009

Amberley Publishing Plc
Cirencester Road, Chalford,
Stroud, Gloucestershire, GL6 8PE

www.amberley-books.com

Copyright © Jacqueline Cameron, 2009

The right of Jacqueline Cameron to be identified as the
Author of this work has been asserted in accordance
with the Copyrights, Designs and Patents Act 1988.

ISBN 978 1 84868 598 7

British Library Cataloguing in Publication Data.
A catalogue record for this book is available from
the British Library.

Typeset in 9.5pt on 12pt Celeste.
Typesetting by Amberley Publishing.
Printed in the UK.

Introduction

No matter how you look at it, Royal Leamington Spa is not the town I used to visit as a child from Warwick. Then, for one and a half penny return on the Midland Red bus I was transported into a new and beautiful world of large shops and tree-lined avenues with Regency buildings. These were the heady days of post-war Britain, where you still queued at the gas works for coke for the fire, toilets were at the bottom of the garden and many homes were lit by gas. Royal Leamington Spa was different — it held a magic all of its own, with its lovely laid-out gardens and upmarket shops, where you looked in the window and dreamed. Shops like Bobby's, Burgis and Colbournes, Frances and Woodward's, where I would stand with my most treasured possession in my hand, a laddered silk stocking, waiting my turn to have the ladder repaired by a very capable and — to me as a young girl of fifteen years of age — elderly lady. Paying for the repair was almost as interesting as having the ladder mended, the money would be put in a grey tube, placed in a funnel and disappear to reappear suspended above on a wire where it would travel to the cashier who dealt with the payment and any change due from a booth at the other end of the store. Gray's was also a firm favourite, as their merchandise was affordable for the most poor among us, and we would rummage among piles of underwear to find vests, liberty bodices and knickers which came down to just above the knee, a firm favourite with the older generation, some of which would probably still be wearing combinations! I can still recall the laughter my friend Janet and I shared when we tried to work out the wonders of a pair of camiknickers! Ration books were still in vogue, and as you only had so many coupons to spend each month they usually went on sweets. Woolworth's was another must for the weekly visit, and as the store was on the one floor everyone converged to a narrow passing place, which opened up into the garden section. People would push and shove to get to the back of the store (especially on a Saturday afternoon when it was particularly busy) mainly I think out of curiosity and in case they were missing something. Christmas, and the cards would all be on display in this corner of the store with the cheapest cards in one section, the slightly dearer cards in another and so on. There were no boxes so there were literally hundreds of cards and envelopes to sort through as people pushed past you. This was least of your troubles, however, because having found your cards you then stood around the counter hoping to catch the assistant's eye to pay for them! There were diaries for two pence half penny and calendars for three pence, and as a young girl with only her pocket money to spend it opened up a new world as I could buy a Christmas present not only for mum and dad but my friends as well. There were some lovely cafés and restaurants in Royal Leamington Spa at this time. There was Bobby's, where only the affluent customer could afford to take afternoon tea served by a band of well-presented waitresses; Patterson's, with its two tier service; and the Cadena, which stood opposite the town hall. Each had a charisma of its own. Another firm favourite at this time was the Pump Rooms, where a trio of musicians serenaded you as you ate your meal and watched the world go by through the large Victorian windows of the restaurant. Afterwards you could take a walk in the Jephson Gardens opposite where for a penny you had the privilege of walking among the well-kept flowerbeds.

Leamington has changed immensely since this time. Builders have ruined lovely old Regency buildings by building far too many matchbox houses on the site of the old Victorian villas, and although the fronts of buildings are, in many cases, listed, the back leaves much to be desired. Royal Leamington Spa has a lot to offer the town's folk and visitors alike with its beautiful impressive stuccoed terraces, lovely tree-lined streets and well-planned and maintained gardens. Some of the buildings have seen better days and lack the elegance they once enjoyed in the early part of the nineteenth century, but the planners are making an effort to retain this external charm by keeping the outside structure of the building. Woodward's on the Parade is a fine example of this; the entire building was gutted and just the outside shell of the building left standing during a recent modernisation programme. However, as you can see from photographs in the book, the builders have managed to retain the original grand design, which is credit to their skill.

Leamington has not always been like this and one has to travel back in time to really appreciate the changing face of the town. It is difficult to compare the bustle of today's Royal Leamington Spa to a sleepy

little village where there were forty-six dwellings until 1800 when there were still possibly no more than fifty dwellings and a population of around 300 people. There is no doubt that the discovery of the spa waters was to have a huge impact on the town. As early as 1656 Sir William Dugdale wrote of the spring of salt water to the west of the church, where the inhabitants make much use of the water in seasoning their meat, making bread and using it as a purging water with great success. The story goes that William Abbotts had sunk several well shafts without success in his search for saline waters, but on 14 January 1784, while in conversation with Benjamin Satchwell, events were to change his luck. Satchwell noticed water bubbling in an adjoining pond and without any more ado he tasted the water, which proved saline. Leamington was soon to establish itself as a town whose waters held medicinal properties, and the pair discovered the villages second spring on Abbotts' land in Bath Lane. This find resulted in the opening of Abbotts' original baths in 1786 and the curative powers of the saline waters were soon acknowledged.

A single-storey structure with a central entrance was erected above the well in Bath Street. There were two reservoirs leading into it, one for warm salt water and another for cold. William Abbotts was sixty-nine years of age when he passed away on 1 March 1805, leaving behind him a legacy which lives on to this day, as you can still drink the saline waters from a pump that can be found outside the Pump Rooms.

Upon hearing about the healing powers of the saline waters all those years ago, an ever-increasing number of wealthy visitors came to the town. Hotels sprung up to cater for the visitors to the town and between 1806 and 1820 there was great change. New buildings intermingled with or replaced the old, and new streets extended to the outskirts of the town, with most of the growth being in the Bath Street/High Street area. With the increased interest in the saline waters there came a need for accommodation to meet the requirements of visitors, who were growing in number, and several hotels were built or altered. The Bedford Hotel was kept by J. Williams and his wife and opened on 25 October 1811. The hotel had fifty rooms, which were soon filled by the visitors. Another hotel of note was the Copps Hotel, which at this time was known as the Royal Hotel and stood in the High Street. The Royal was slightly larger than the Bedford Hotel and had 100 beds. Improvements were the order of the day and by 1830 the Gloucester, Blenheim, Castle, Shakespeare and Union Hotels had all been renovated and refurbished.

The spa town had now divided itself into two levels of society: on the one hand there were the wealthy and influential visitors and on the other hand the working classes, who were very much under privileged. This was no more prevalent than in the period 1820 to 1850, when Leamington's popularity as a spa town had began to wane and it was becoming a permanent residence for a large number of retired people and high ranking members of the armed services. The railway's arrival in the town also had an impact and professional men would live in Leamington Spa and commute each day to Coventry, Birmingham and some even travelled to London. Things were set to change again and from 1900 to the 1930s poor old Royal Leamington Spa earned the title 'poor, proud and pretty' as many of the fine houses stood empty and neglected. Even the retirees, if they had not passed away, were looking towards more humble abodes as their capital diminished. Large Victorian houses take a lot of heating and heating costs money.

Royal Leamington Spa has changed an awful lot since the days of the Aylesford Well, the fascination of the saline waters and Major Harry Gem, the founder and president of the Leamington Tennis Club, which was founded in 1872 and was the first tennis club in the world. No mention of Leamington Spa would be complete without reference to Queen Victoria whose statue stands proudly on a plinth outside the town hall, erected by the people of Royal Leamington Spa and unveiled by Lord Leigh in 1902.

Leamington Spa still has a certain amount of the charisma and charm of its early days if you look through the large volume of traffic and the congestion that goes with it, traffic lights, pedestrian crossings and vast amounts of visitors and people who have moved into the area, you will see the beautiful flowers of Leamington in Bloom and find the heart of the town which is still beating as strongly as it always has done. It is a pleasure to live in Royal Leamington Spa, and I am eternally grateful to Alan Sutton for giving me the opportunity to write about it.

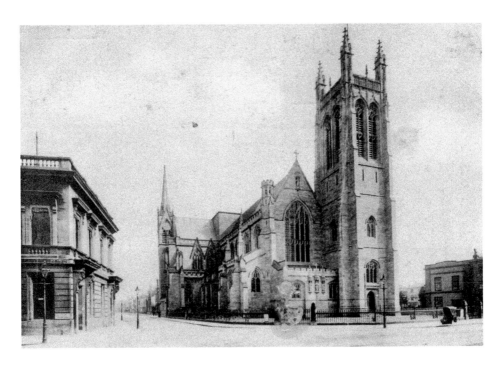

The Post Office and Parish Church

Built from designs by Mr Charles Elliston, the architect in Bath Street, the post office building was opened on 25 May 1846. It had letter boxes placed each side of the doorway and a large illuminated clock in the window which gave the correct time.

The parish church of All Saints was, up to 1800, the only place of worship in the village of Leamington Priors, with the village consisting of a manor house; three farms, with approximately fifty labourers; a post office, albeit small; a water mill; a parish poor house; a smithy; a millwright shop; and no village would be complete without its inns, in this case two! Standing on the south bank of the River Leam, Mr Willes was the lay preacher of the church at this time. Over the years the church has been extended many times, until 1843, when, no longer practical to extend any further, the church was rebuilt by J. C. Jackson, with the tower being added around 1898-1902. All Saints' is now the largest church in Warwickshire and one we are very proud of.

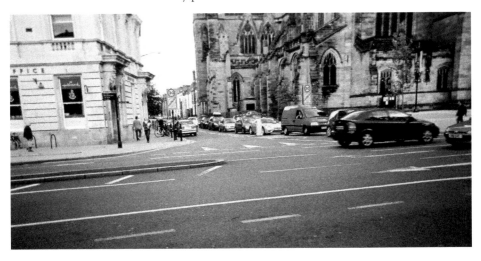

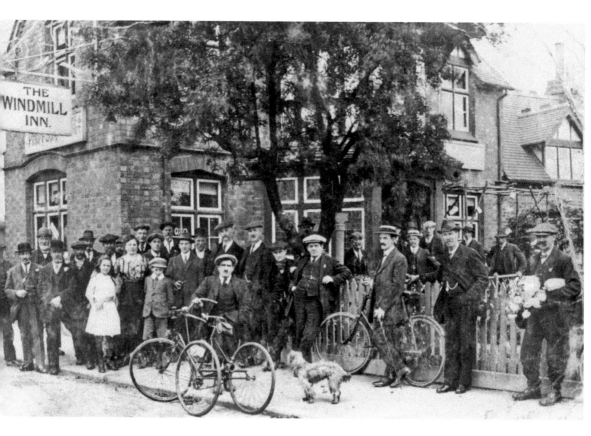

The Windmill Inn

The photograph above shows local allotment holders outside the Windmill Inn, Tachbrook Road, and was taken around 1917. The building still stands to this day and is a public house and restaurant. The windmill has long since gone.

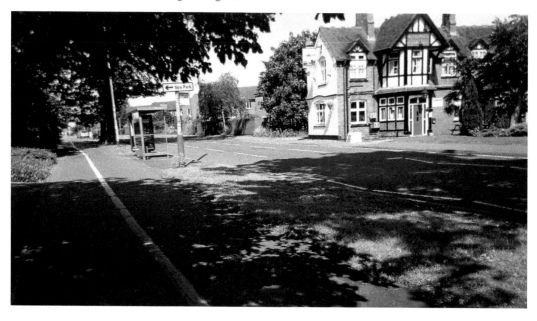

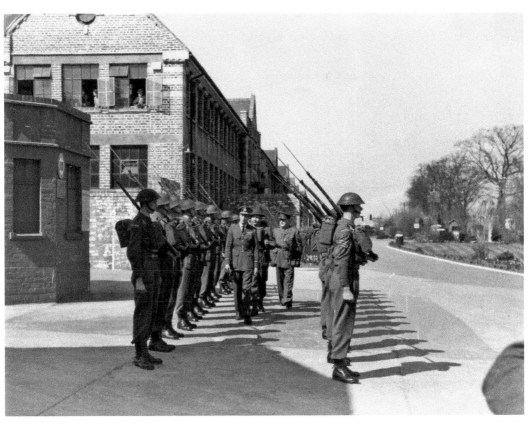

Lockheed

On parade, and we see the Lockheed Home Guard being inspected while the office staff look on during the Second World War. Things have changed a great deal over the years as you can see.

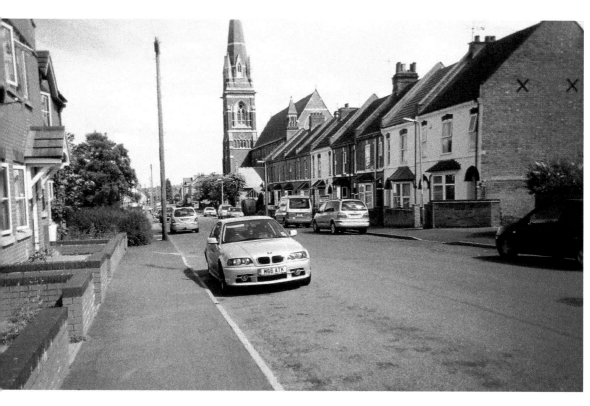

St John's Church

Built by John Fell, who was the mayor of the borough in 1887, St John the Baptist stands in Tachbrook Street. At the time of its build it had the support of the Revd Canon Young of Whitnash, Mrs Matthew Wise and Dr Jephson. In the early Victorian period it was often the practice to build churches at the centre of a new development, and St John the Baptist is a fine example of this practice.

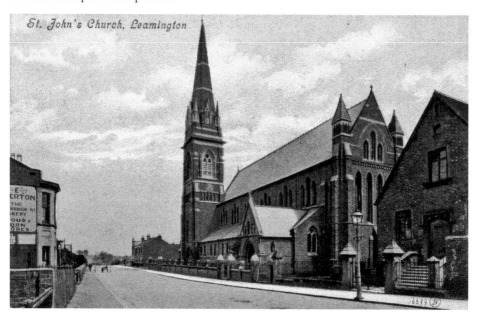

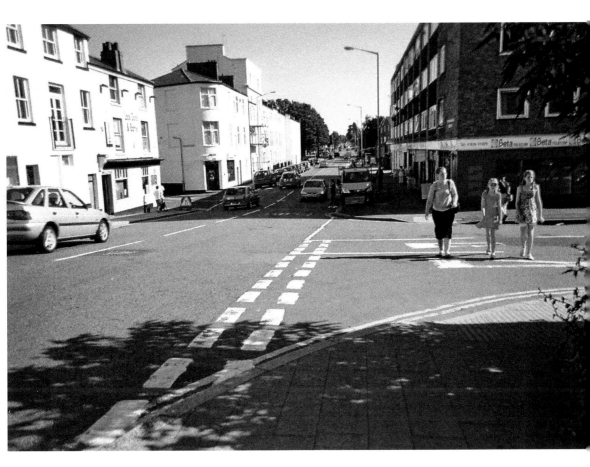

Brunswick Street
Brunswick Street, pictured, is an extension of Clemens Street and was started in 1827.

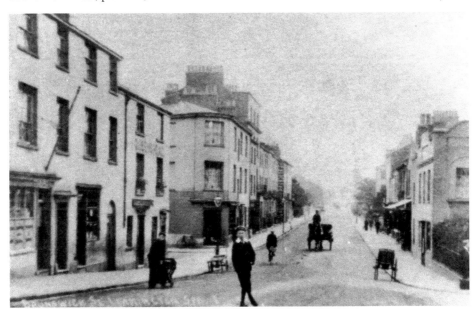

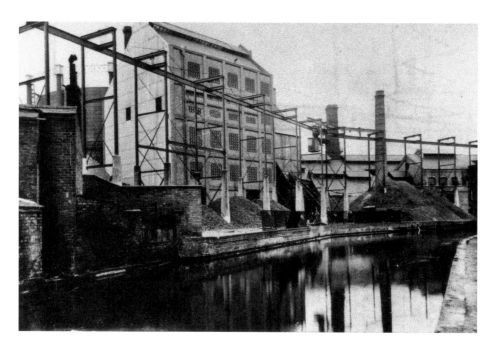

Gas Works

An early photograph of Leamington Gas Works has printed on it the words 'Established in 1819', yet contrary to this it has always been a talking point when it comes to who actually laid claim to the first public lighting, Warwick or Leamington? It has been claimed that Warwick was the first to provide the lighting of eighteen lamps in Union Row in 1823, but in view of the date on the Leamington Gas Works one can appreciate all the confusion. Where did the gas come from, Warwick or Leamington? The gas holders were demolished in 1982. The gas works have now been removed and the site has houses and apartments built on it.

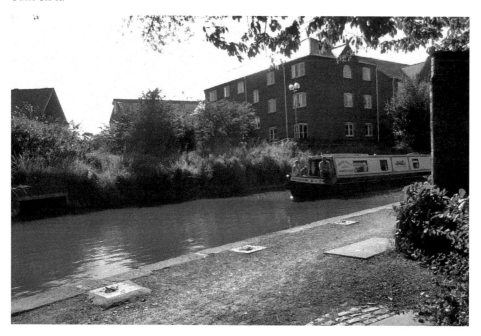

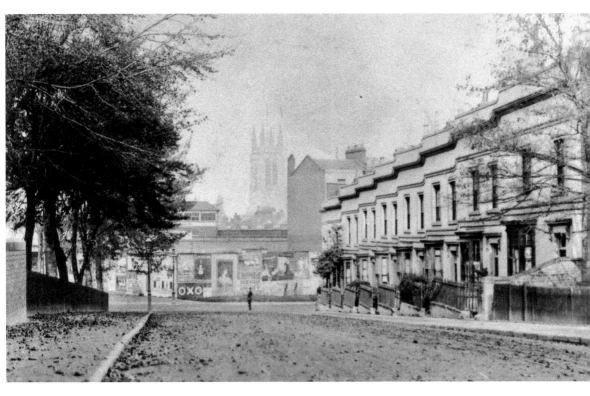

Tachbrook Road

The first house to be erected in Tachbrook Road was in the early part of the nineteenth century and was built on the corner where the road met the High Street. To further enhance the area the Arboretum Hydropathic Establishment was erected in 1863, further along the road.

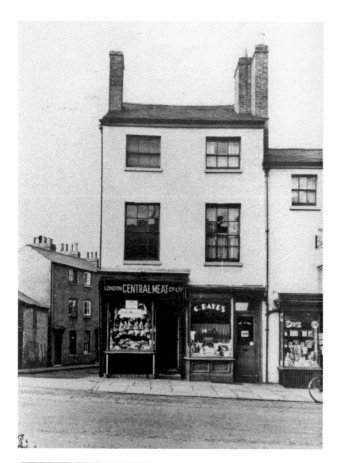

London Central Meat Company
The London Central Meat Company's shop at 14 Clemens Street *c.* 1950. The shop closed in 1960 to be replaced the following year by Baxter's Limited, a butcher's. The Somerfield supermarket chain now trades on the site.

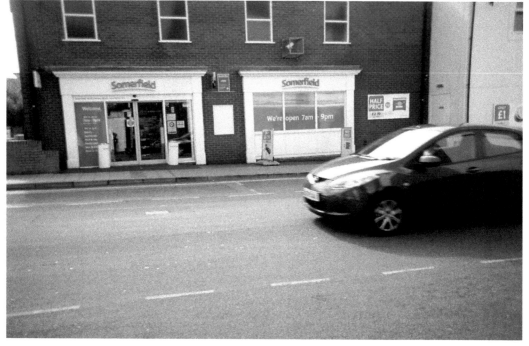

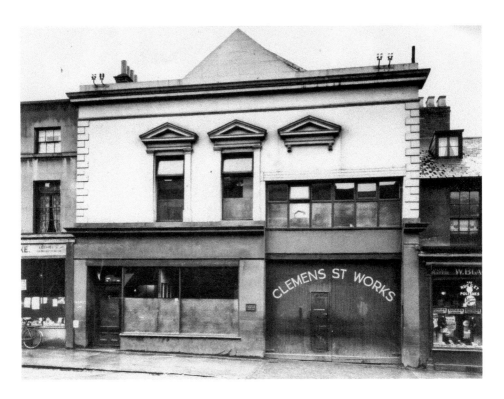

Clemens Street

The first Non-conformist chapel was built in 1816. By 1848 it had become a theatre, only to revert back to a Congregational Free Church in 1866. Around 1910, prior to it being used by Automotive Products Limited, the Zephyr Carburettor Company traded in the building in Clemens Street.

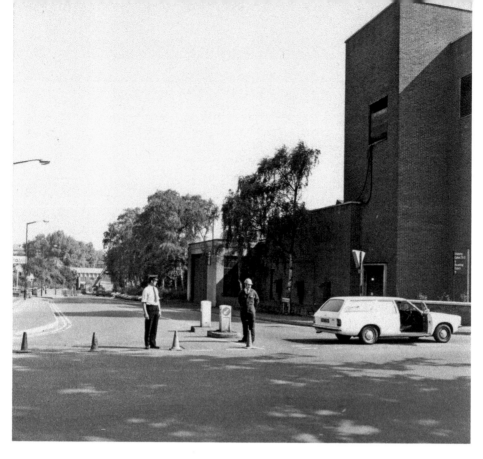

Princes Drive

An unusual view of the top of Princes Drive and far removed from how busy the road gets now. The guards were Ford Motor Company employees, and the road was closed so that the footbridge could be installed to allow employees to cross safely. The photograph above was taken in 1974.

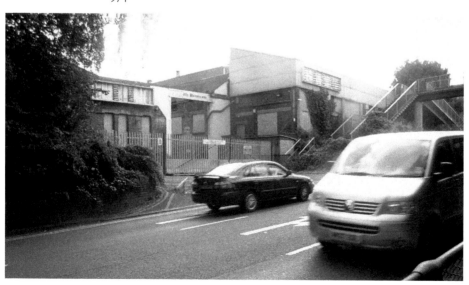

Nothing Changes!

I included this photograph of Princes Drive toward the Victoria Gardens and the destructor because I had managed to capture the same tranquil scene thirty years later. However, I have to say the opportunity does not happen very often!

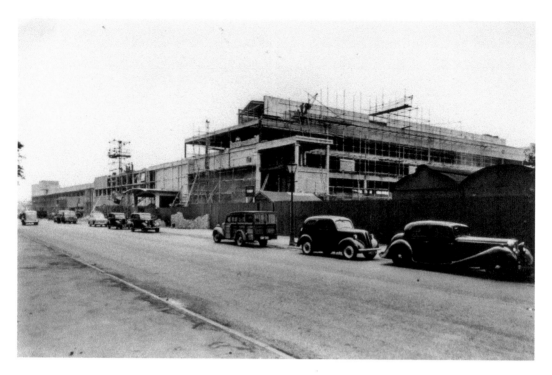

South Front of the Imperial Foundry
The Imperial Foundry is seen here under construction by Turrifs of Warwick.

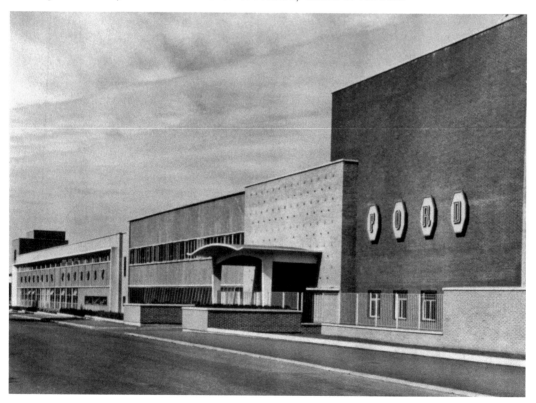

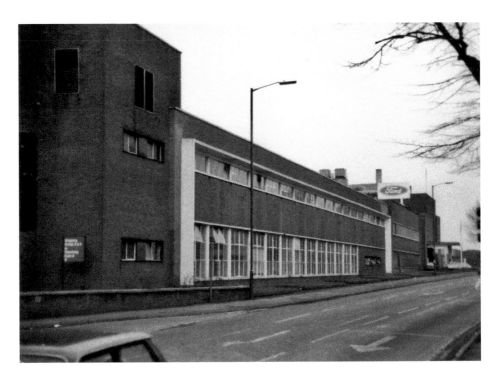

Ford Motor Company Limited

The photograph above shows the Ford Motor Company entrance during its transition period in 1957, when the company was still known as the Imperial Foundry. Further modifications were to take place at a later date but it's nice to look back and see the old place and remember how it used to look.

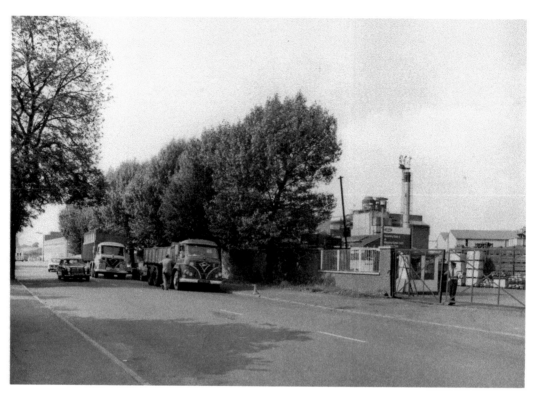

No. 5 Gate

Still with Ford Motor Company and here we see the delivery lorries waiting to shed their load, which was usually scrap metal in 1977. It all looks very sad now.

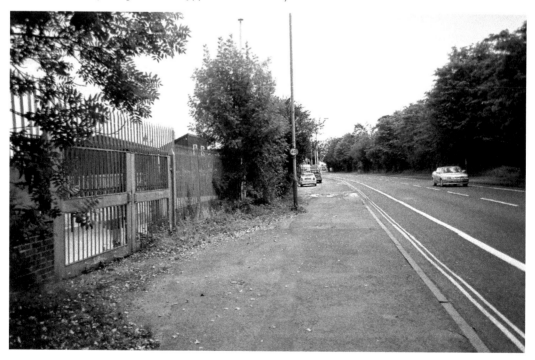

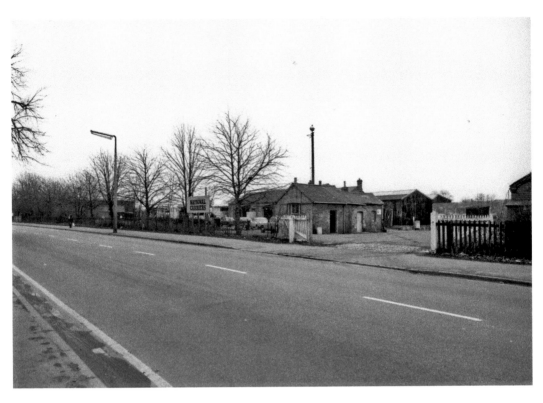

The Myton Road

Here we see the National Carriers site on the Myton Road leading towards the railway station. It hasn't changed a great deal, but nevertheless the tranquillity has gone.

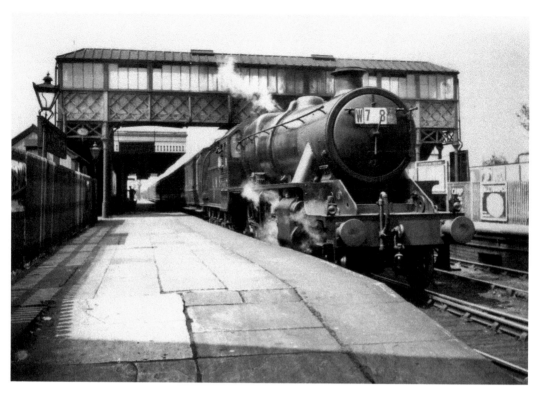

In Avenue Railway Station
The top photograph shows the express train No. 2983 standing at the platform at the Avenue Road station in 1937.

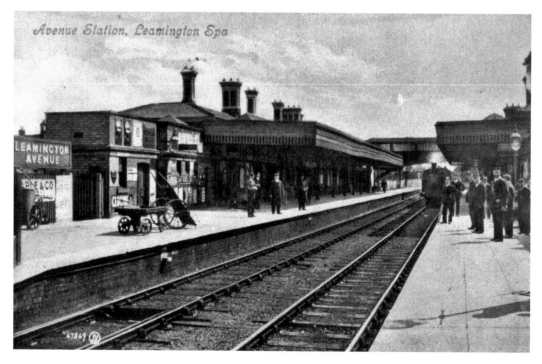

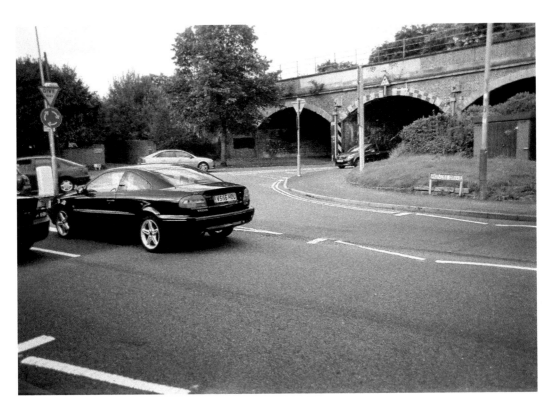

Milverton Station

The first local railway line to reach the town was built in 1844, when a branch line from Coventry reached Milverton on the outskirts of the town. It was almost nine miles long. Above we see how the Milverton Station site looks today.

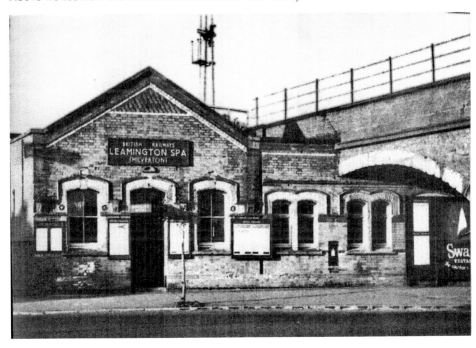

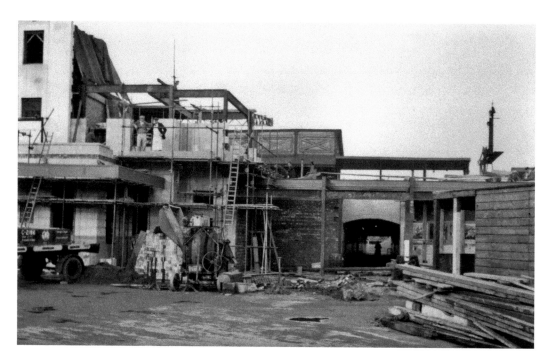

Great Western Railway

The above photograph shows the original Great Western Railway Station, built on the site of Eastnor Terrace in 1852. This came after the direct route to Rugby, which had been completed a year earlier in 1851. To enable the Rugby route to be built the Old Milverton Station was demolished and the platform extended on the main route in 1883. The main route to London from Leamington was in fact demolished and rebuilt in 1936-38. The Great Western Railway Station still stands on the same spot to this day, with various modifications taking place over the years.

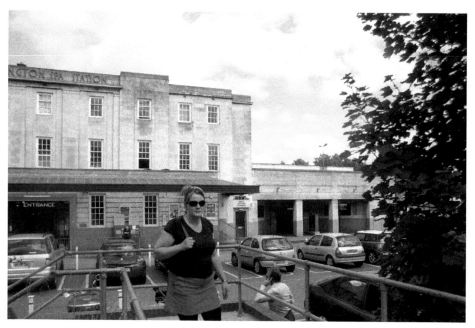

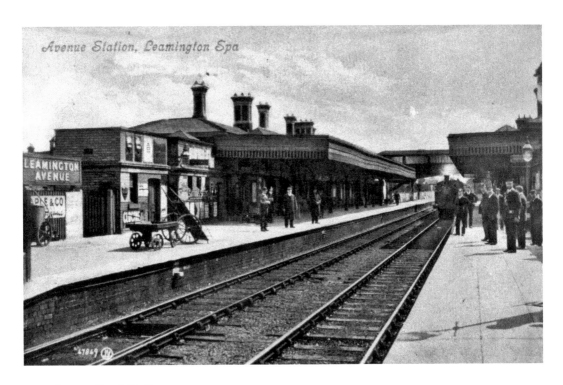

Avenue Station, Leamington Spa

Avenue Road Station

The first railway station at Avenue Road was no more than a wooden shed, but due to public demand this was replaced by a new and extensive railway station. Built in the Italian style, the new station was officially opened in March 1860. In 1964 passenger services between Coventry, Leamington and Rugby were discontinued, and the station and the track to Rugby were both demolished in 1968. Today, as you can see from the photograph, it is just waste land!

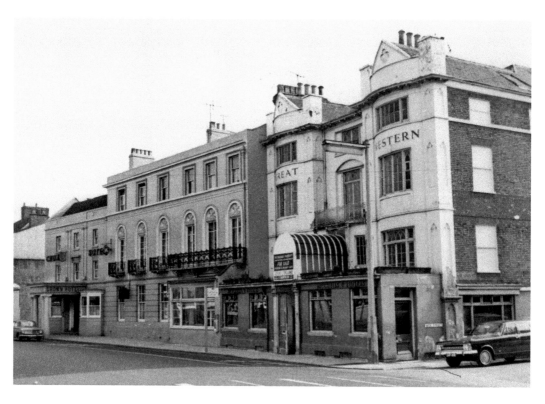

Great Western and Crown Hotels

This photograph was taken in March 1967. The Great Western and Crown Hotels prospered for many years.

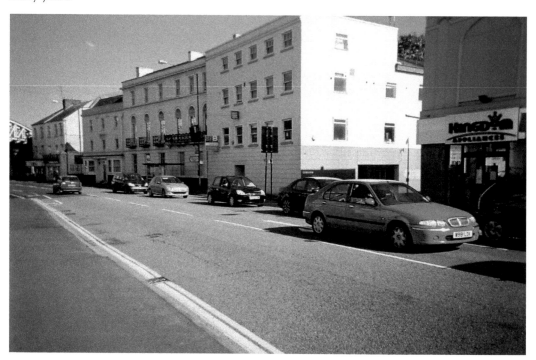

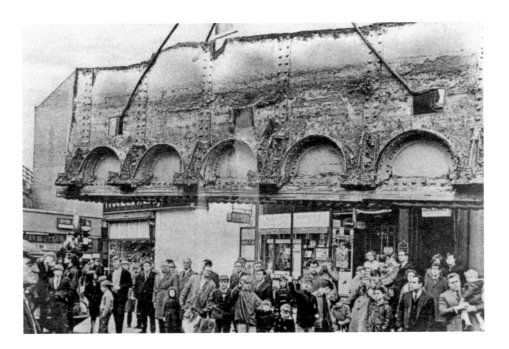

Railway Bridge, High Street

This photograph shows the bridge after it had been demolished in the late 1960s. The need for the bridge arose after the arrival of the Milverton to Avenue Road Railway, and in order to build the bridge over the junction of High Street and Clemens Street two houses of note were demolished. Namely, the recently-built Curtis Original Baths, which stood on the corner nearest the station, and the Copps Royal Hotel opposite. The LNWR Resident Engineer R. B. Dockray was the bridge designer and the bridge was a tube weighing 170 tonnes, composed of wooden members. The bridge had the largest span of its time in England and raised a lot of interest from near and far. It was officially opened on 23 September 1850. Iron Pillars were placed under the centre of the bridge in 1861 to strengthen it.

Drovers Trail
For many years the Drovers could be seen driving their animals through the back streets of the town. Here is pictured the Drovers Trail, which is adjacent to Gordon House.

Gordon House

Gordon House was named after the heads of the ducal house of Gordon. In 1810 the Duchess of Gordon was attracted by the rising fame of the mineral waters. Gordon House was an ordinary cottage (which was in vogue at this time) built of bricks, un-cemented and having a parlour with a sand-covered floor. It was but a short distance from the Old Bowling Green in Church Lane.

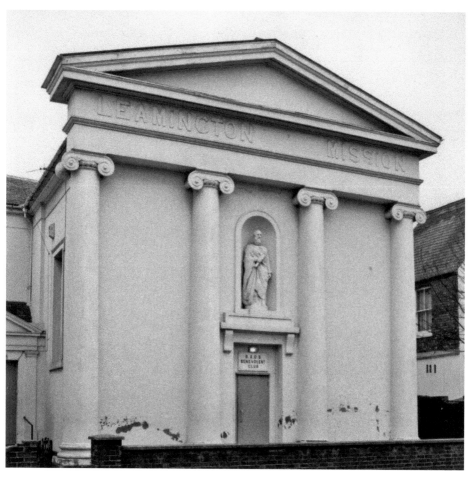

Roman Catholic Church
Built to the design of Russell and Mitchell in 1828, the first Roman Catholic place of worship was in George Street and stood on the corner of George Street and Priory Terrace. Dedicated to St Peter, the first priest in charge was the Revd W. Cunningham. The building stands today and is still used for worship, albeit of a different faith.

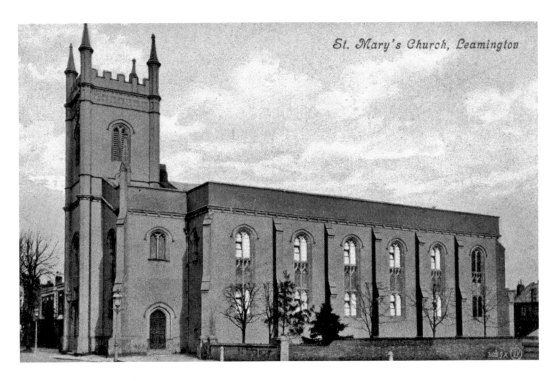

St. Mary's Church, Leamington

St Mary's Church

The site for this church, as donated by Mrs Hitchman, the widow of Dr Hitchman, who also donated a large sum of money which enabled St Mary's to be built by John Cundall between 1877 and 1878. Built in brick, complete with a prominent steeple, the interior is brick lined. Situated in Old Town, this lovely old church is one of the town's oldest religious buildings.

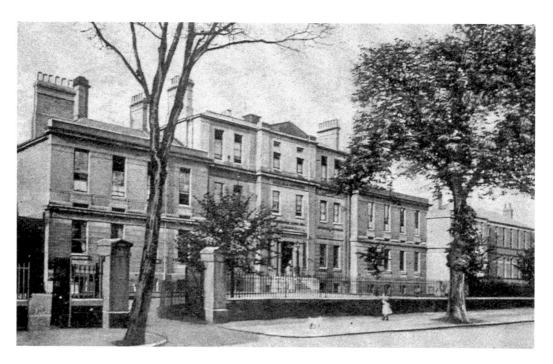

The Warneford Hospital

This photograph shows the Warneford Hospital, which was established in 1832. The Hon. C. B. Percy of Guy's Cliffe laid the foundation stone on 10 April 1832. Two further wards were added in 1838 and in 1856. The two upper wards of the original building were opened and furnished mainly due to the efforts of Dr Jephson. The East Wing was then added in 1857. Expansion continued at the hospital until January 1900, when the local M.P., Princess Christiana, opened the Victoria Wing. The hospital has now been demolished and a new housing estate has been built on the site.

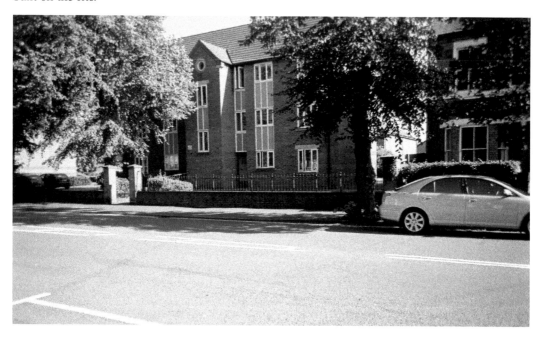

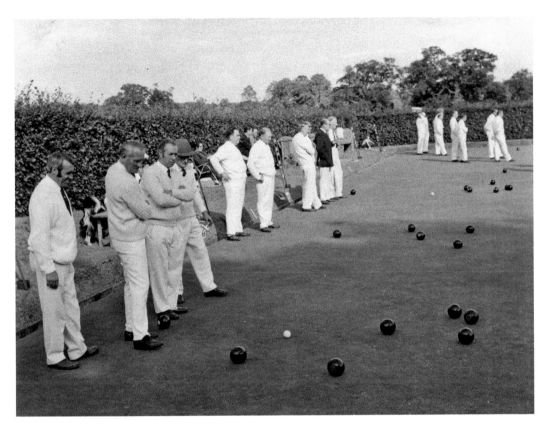

Bowling Club

The Royal Bowling Club was formed around 1909 with the original green being located at the Victoria Bridge in Avenue Road. Forming part of the Victoria Park, the club moved to Archery Road. Here the greens are frequently in use by the English Women's Bowling Association and the All England finals, which are still being held yearly to this day and form part of the town's calendar of events.

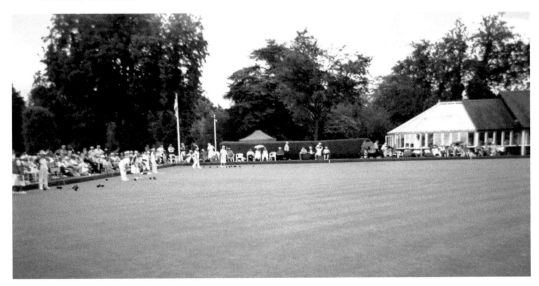

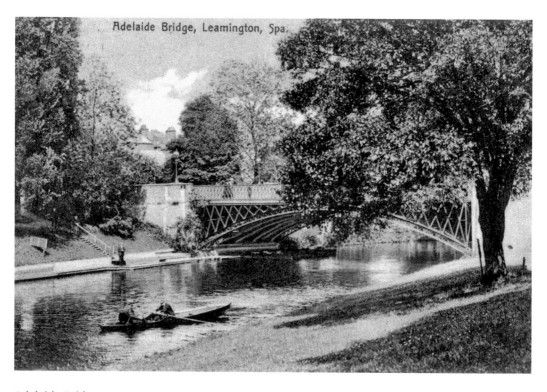

Adelaide Bridge, Leamington, Spa.

Adelaide Bridge

Built by J. Heritage of Warwick, the Adelaide Road Bridge was first opened in 1850. This was brought about by the need to travel between Warwick and Milverton without using the Victoria Bridge in the centre of the town.

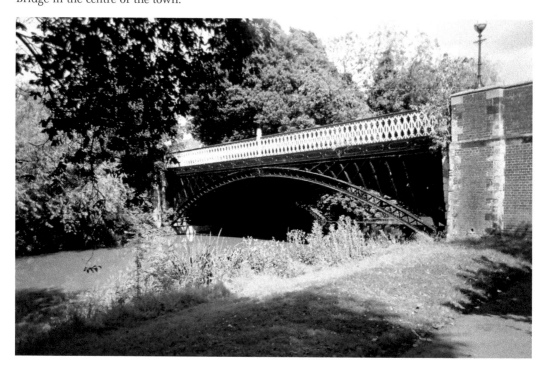

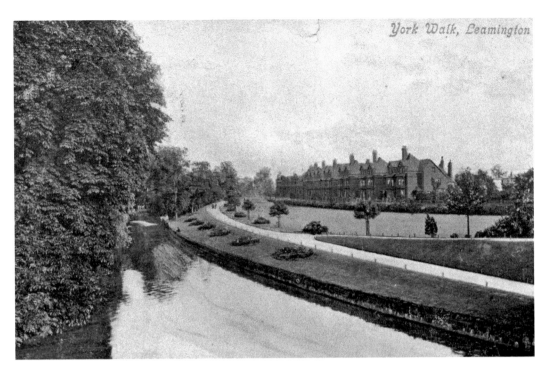

York Walk, Leamington

York Walk
York Walk promenade taken early last century, the flower beds that graced the river bank
unfortunately no longer exist.

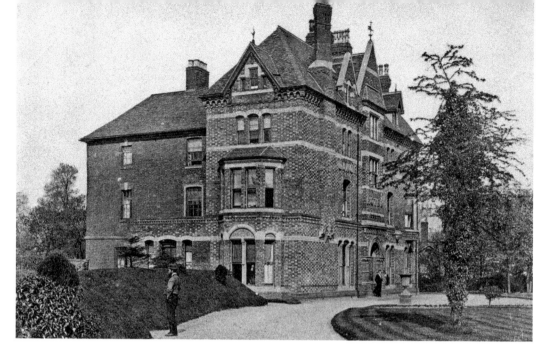

Manor House Hotel

Originally a magnificent residence, the Manor House was the home of Matthew Wise. It was reached by an avenue of trees and it was this line of foliage that gave 'Lower Avenue' its name. There was another avenue of trees that ran from the London Road into the Manor House grounds and this was the reason for the two large gates on either side of the Manor House Hotel. The Manor House has also got connections with lawn tennis, and a tablet on the lawn reads: 'In 1872 Major Harry Green and his friend Mr J B Pereira joined with Dr Frederick Haynes and Dr A Wellesley Tomkins to form the first lawn tennis club in the world and played the game on nearby lawns. This plaque was erected on the occasion of the centenary celebrations on 11th June 1972.' A fountain was added in the nineteenth century. The house was run as a hotel for many years until a builder converted the lovely Manor House Hotel into sixty-six luxury apartments.

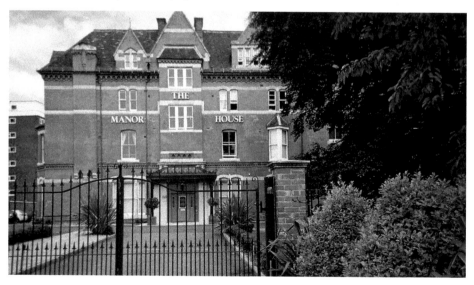

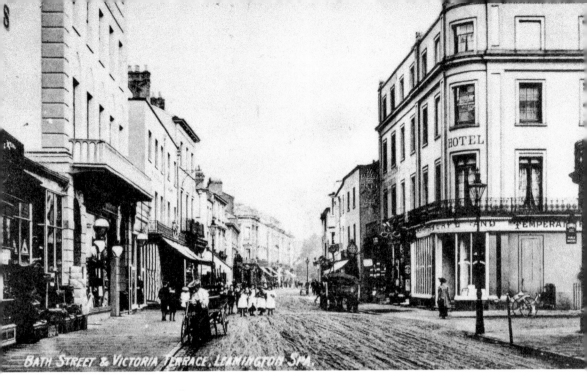

BATH STREET & VICTORIA TERRACE, LEAMINGTON SPA.

The Temperance Hotel

Stood on the corner of Regent Place and Bath Street, the Westminster Temperance Hotel and Coffee Tavern was known as the haven for all teetotal travellers. The Temperance movement being against alcohol, and as Leamington Spa had its fair share of brewing houses and inns at this time, the Temperance Hotel would have been a retreat for those who did not participate in the demon drink! The building still stands to this day but is now the home for a florist.

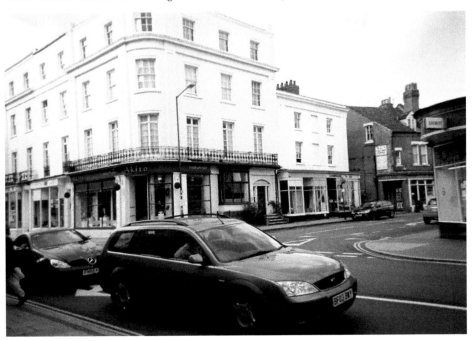

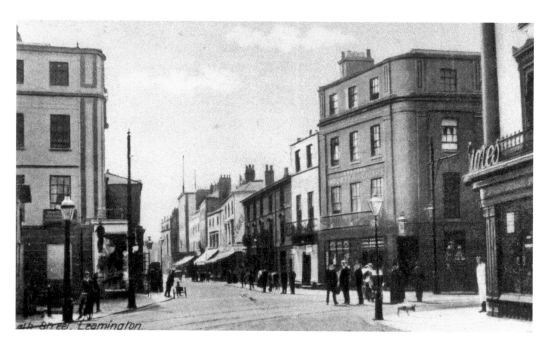

Bath Street

This picture shows the building on the left-hand corner of Bath Street and Church Walk. It was originally a public library, from 1858 until 1873, and for a time the ground floor was occupied by the *Courier Press*. The building was erected around 1814-15. After the purchase of another 1,000 books, the lending department was opened in the library in September 1859. A Ladies' Reading Room was also added in April 1863. Due to its popularity the library outgrew itself in 1864. Currently it is the premises of a local drinking establishment, the Jug and Jester.

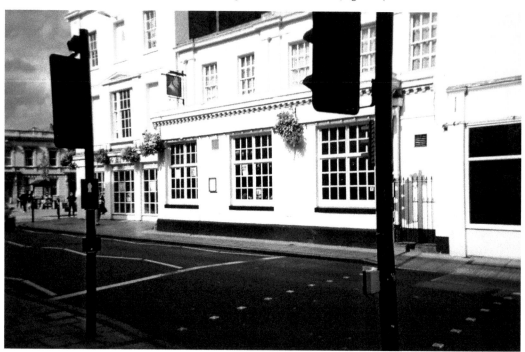

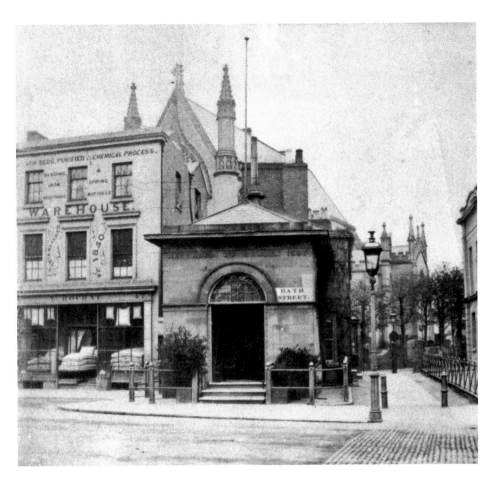

Aylesford Well

The Well House, which was erected over the original spring, was demolished in 1961. The photograph above was taken prior to the adjacent shops being demolished around 1905. We now have this blue sculpture in its place.

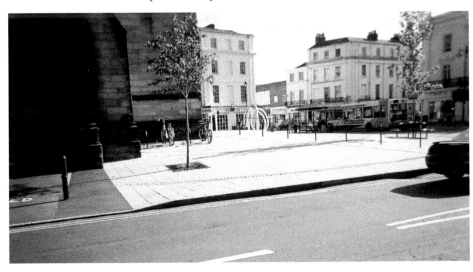

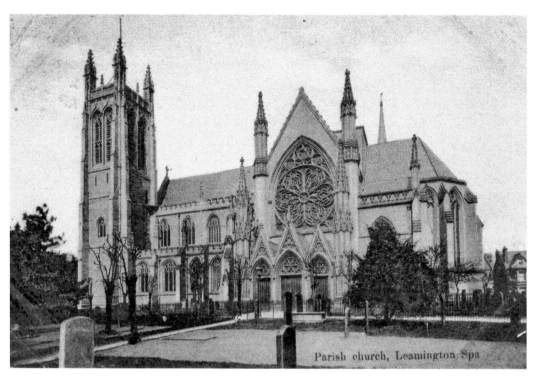

Parish church, Leamington Spa

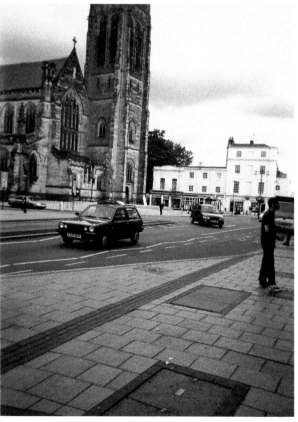

Parish Church of All Saints

The parish church of All Saints until 1800 was the only place of worship in the village of Leamington Priors, with the village consisting of a manor house, three farms, approximately fifty labourers, a post office — albeit small, but a post office none the less — a water mill, a parish poor house, a smithy, millwright shop and no village would be complete without its inns, in this case two! Standing on the south bank of the River Leam and with a population of only 300, Mr Willes was the lay preacher of the church at this time. Over the years the church has been extended many times. In 1843, when, no longer practical to extend it any further, the church was rebuilt by J. C. Jackson with the tower being added around 1898-1902. All Saints' is now the largest church in Warwickshire and one we are very proud of.

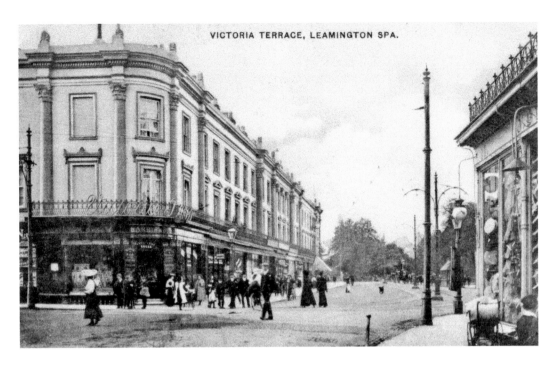

Victoria Terrace

Taken around 1908, this impressive view of Victoria Terrace, which was designed by William Thomas in 1873, gives us a look at whom conducted business there at this time. To name but a few: Harris, on the corner; Dickie Lloyd, the shoe maker next door; and the baby linen shop, owned by the two Miss Herribins. Originally, the right-hand section of the building was occupied by the Victoria baths. In sharp contrast to today there is no traffic! As you can see by the coloured photograph the wrought ironwork has stood the test of time but the poor old gas lamps have gone.

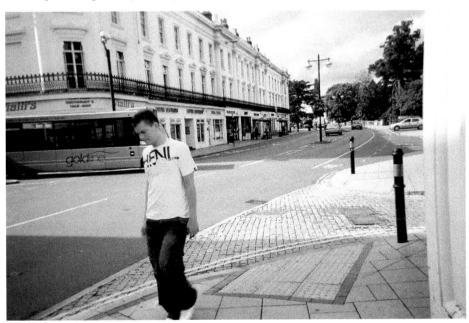

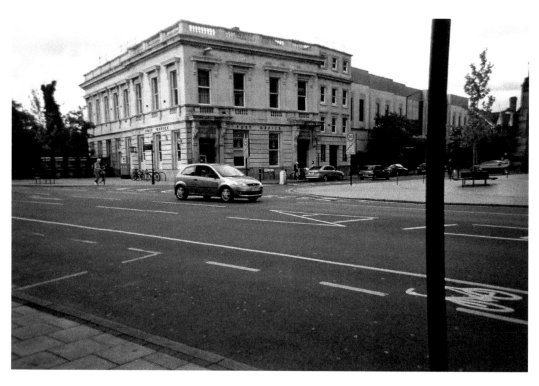

The Main Post Office

Built from designs by Mr Charles Elliston, the architect in Bath Street, the building was opened on 25 May 1846. It had letter boxes placed each side of the doorway and a large illuminated clock in the window which gave the correct time.

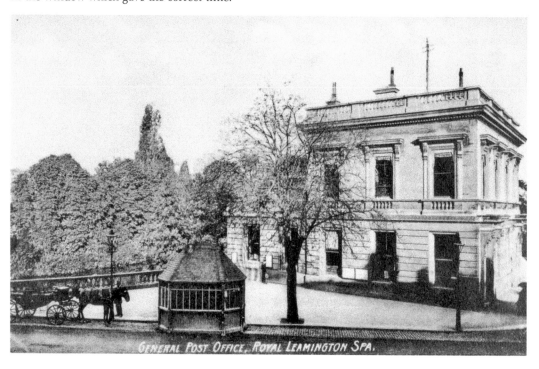

GENERAL POST OFFICE, ROYAL LEAMINGTON SPA.

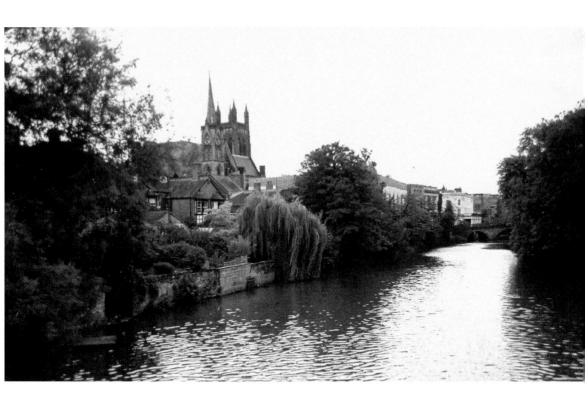

The River Leam

This view of the River Leam shows All Saints' church in the background. Photographed in 1922, this picture would have been taken from the Mill Weir and Suspension Bridge.

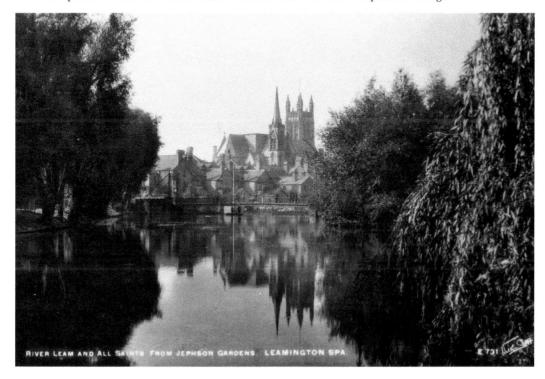

RIVER LEAM AND ALL SAINTS FROM JEPHSON GARDENS. LEAMINGTON SPA E 731

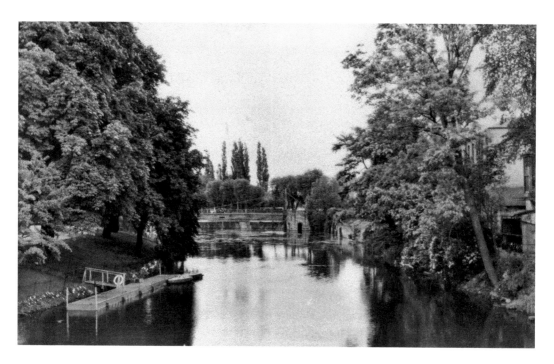

The Mill Suspension Bridge

The Mill Weir and Suspension Bridge joins the Jephson Gardens and the smaller Mill Gardens, and a stone tablet on the South West End of the bridge reads: 'Opened June 1903 by Alderman Davis (mayor). Wm. De Normanville, Engineer'. This is a lovely old bridge that was designed on the lines of the Albert Bridge in London but — unlike its famous counterpart — minus the lights. Down the River Leam, a little from the sluice gates at the right-hand side of the weir as we look at the photograph, was the site of the old mill.

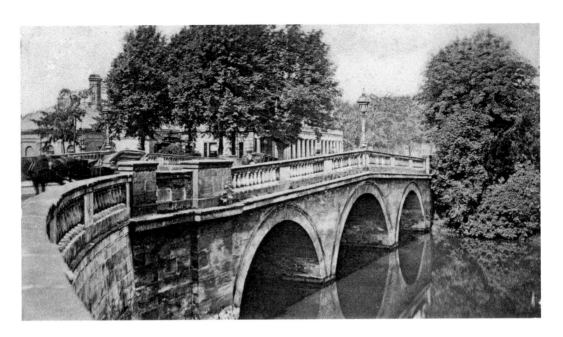

Victoria Bridge

The Victoria Bridge played a major part in joining the Old Town to the south and the New Town to the north of the River Leam. With the popularity of the spa waters increasing it was becoming clearly obvious that the original bridge was too narrow to take the flocks of visitors to the town in the early nineteenth century and the result of this was the rebuilding of the bridge in 1808-9 by Henry Couchman Junior. Mostly financed by Mr Edward Willes and Mr Greatheed the original design of the bridge was in the Gothic style. Due to public opinion the bridge was widened again in the 1830s after major consultation. Dr Jephson laid the foundation stone on the north-east abutment on 14 August 1839, with the final coping stone being laid on Queen Victoria's birthday, 25 May 1840. From this date further repairs have taken place including the balustrades, which were largely replaced in 1984. Prone to flooding, the River Leam has caused various safety concerns over the years.

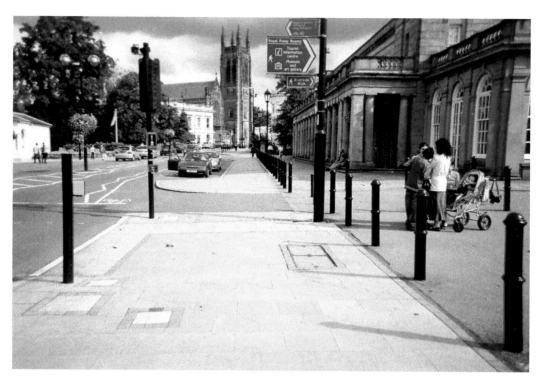

The Royal Pump Room and Parade
Taken around 1910, this photograph shows the tram on its way up the Parade and the ornate brackets of the gas lights.

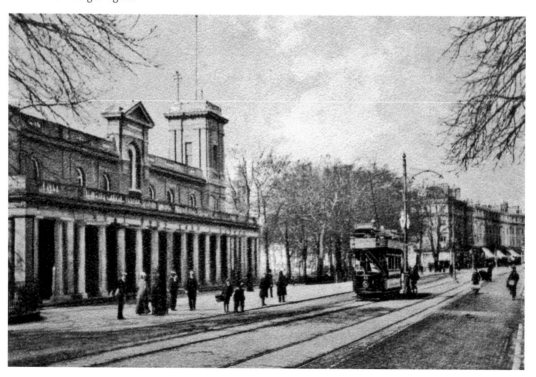

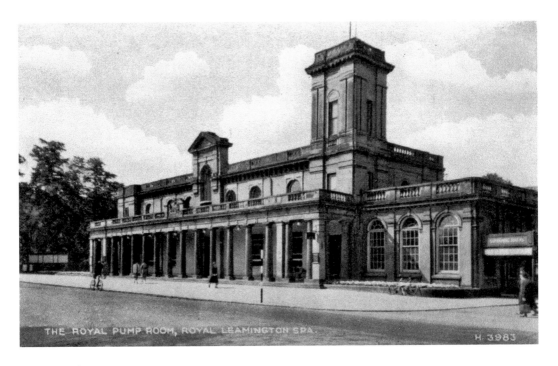

THE ROYAL PUMP ROOM, ROYAL LEAMINGTON SPA. H. 3983

Weather Tower

This picture shows the Pump Rooms complete with the weather tower. Designed by C. S. Smith of Warwick and built on land belonging to Bertie Greatheed, this building was the brainchild of a group of business men, who met and came up with the idea in 1813. Although it was not properly completed for five years the Pump Rooms were actually opened for business in 1814. The weather tower was later to be demolished but the building still stands to this day looking as much the same as when it was built, except now it houses the library, the town's museum and the tourist office.

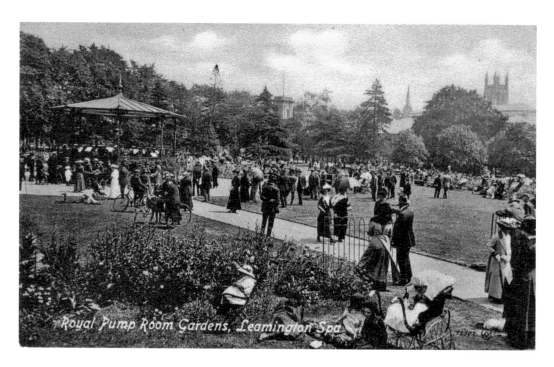

Royal Pump Room Gardens, Leamington Spa

Pump Room Gardens

From their opening in 1814 the Royal Pump Rooms promenade covered the existing gardens as far as the present central path leading to the York Road Footbridge. It was after the local Board of Health acquired the building that the public were admitted free of charge. Prior to this you could only enter the gardens if you subscribed to them. Today they are a popular venue, both for young and old. Events such as the Peace Festival are held on them, the brass bands play in the bandstand on Sundays and special occasions and the local fair also enjoys the delightful setting of the gardens. Although the town no longer hosts the yearly flower show the local farmers' market uses the perimeter every month where people can buy fresh produce if they so wish.

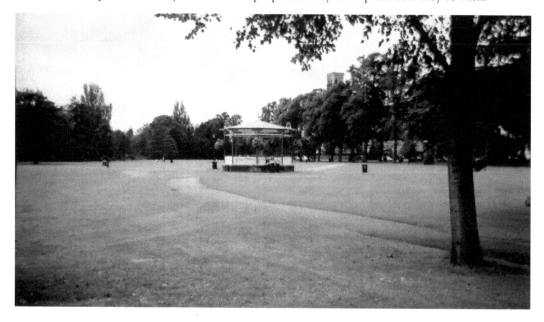

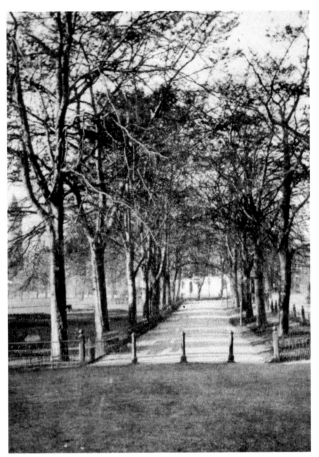

Linden Avenue
Looking very peaceful when this picture was taken, you can just make out the iron arch, which was erected to celebrate Queen Victoria's golden jubilee. The trees were planted during the early part of 1828. This is still a popular walk and benches are now available to rest a while and admire the adjacent Pump Room Gardens.

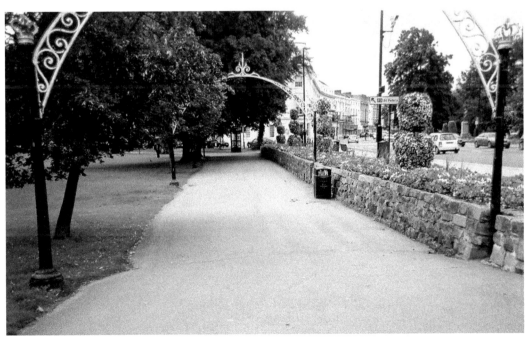

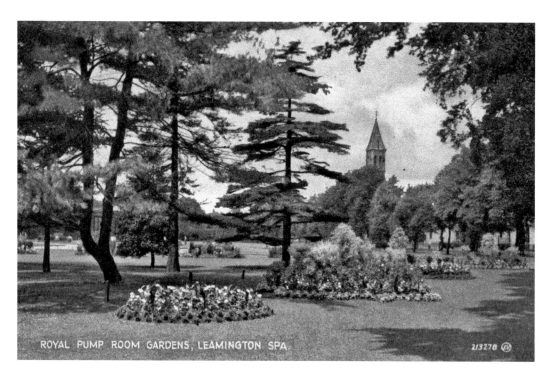

ROYAL PUMP ROOM GARDENS, LEAMINGTON SPA

Across the Gardens

I love this view of the Pump Rooms as it shows St Peter's church when it still had its famous 'pineapple' tower. The church was opened on Thursday 18 August 1864, before the tower was added. A fire that began in the organ brought about the demise of the steeple.

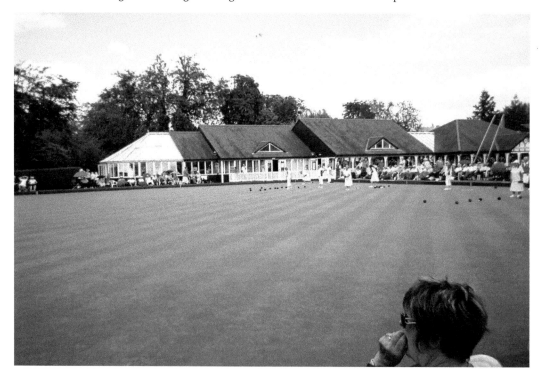

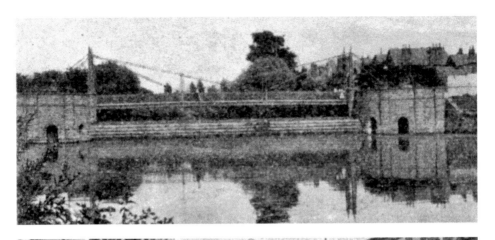

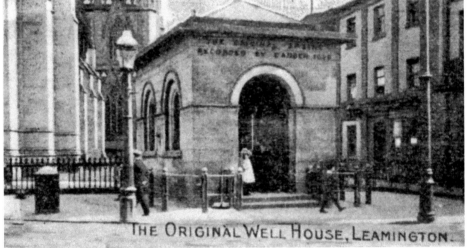

THE ORIGINAL WELL HOUSE, LEAMINGTON.

A Random View
A look around the town.

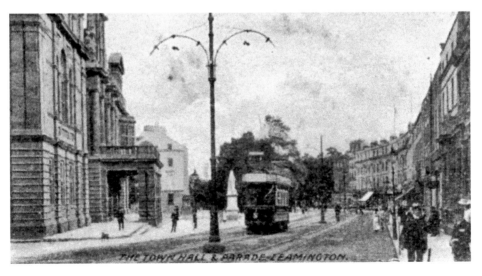

THE TOWN HALL & PARADE, LEAMINGTON.

49

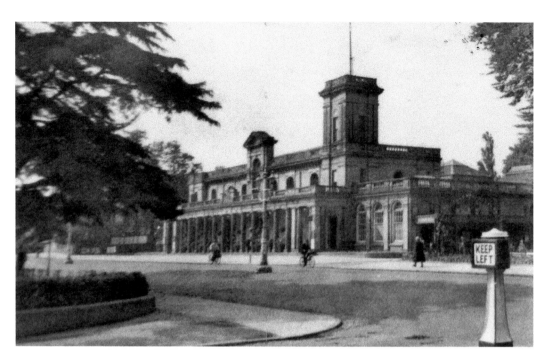

'Keep Left' Bollards

This delightful photograph shows the old 'keep left' bollards that stood at the end of Newbold Terrace. It is interesting to observe that when this photograph was taken the weather tower was still standing and yet to be demolished.

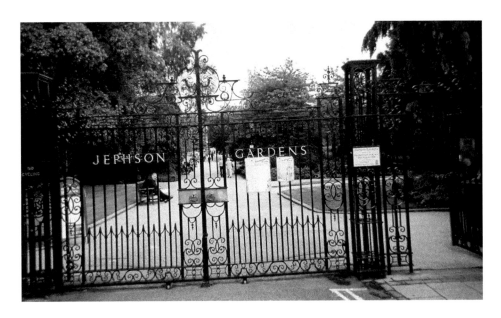

The Jephson Gardens, Parade Entrance

Designed by David Squirhill, the Jephson Garden Entrance is a fine example of an Italian-style gatehouse and gives access to the gardens from the main Parade. In order for the gatehouse not to overshadow the Pump Rooms a maximum height of thirty feet was agreed. The gardens were named after Dr Henry Jephson, a man who held a great deal of respect from the local community and from the many famous people who were listed among his patients. To the left of the entrance stands the Hitchman Fountain, which was erected on the site of the former Strawberry Cottage. Although some changes have been made to the gates themselves over the years and a renovation programme was carried out on the fountain, the entrance looks as it always has done, an inviting entrance to the town's prestigious gardens. When I was a child you had to pay to go into the gardens, but they are now free and open to everyone.

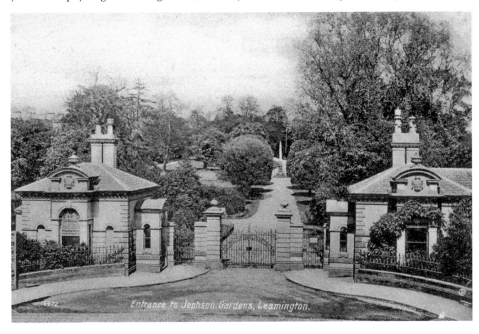

Entrance to Jephson Gardens, Leamington.

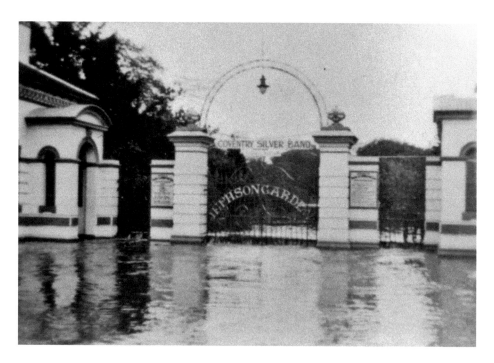

Swollen River Leam

Taken in 1932, the photograph above shows an entirely different picture of the entrance gates to the Jephson Gardens. The River Leam had burst its banks and the town was flooded, including the Pump Rooms and the Jephson Gardens.

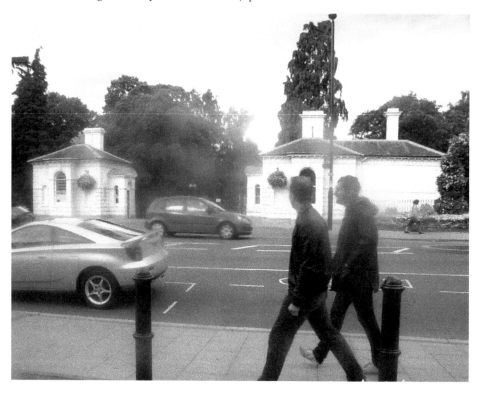

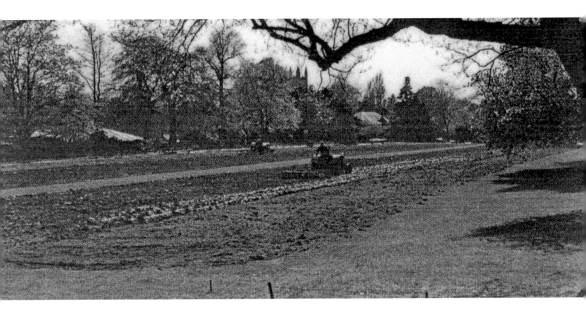

Ploughing

During the Second World War ground was at a premium, rations were getting scarce and the need to grow, or appear to be growing, food fell upon the locals. The Jephson Gardens were no exception, and here we see a tractor preparing the land for sowing. In comparison, the garden now contributes greatly to the town's success in Leamington in Bloom. This is largely thanks to the untiring effort of John Carrier and Nigel Bishop who, with a team of enthusiasts, have achieved great success over the years.

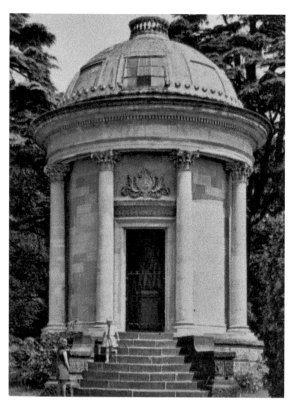

Jephson Memorial

The memorial was erected in the Jephson Gardens in 1848-9 as a tribute to Dr Jephson. This was in recognition of his contribution to the success of the town. The statue of Dr Jephson standing inside the building was carved by Peter Hollins and would have been admired by the doctor, who did not pass away until 1878. The statue is still a focal point of any tour of the gardens.

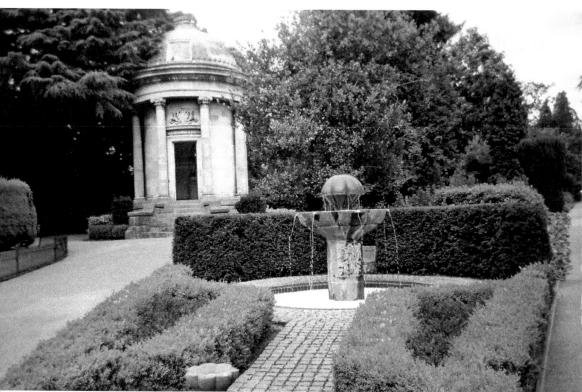

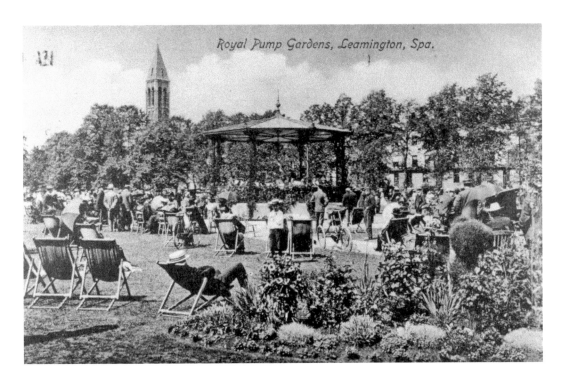

Royal Pump Gardens, Leamington, Spa.

The Bandstand

My memories as a child of the famous bandstand was to sit in the Pump Room Gardens on a Sunday afternoon with my parents and sister and listen to the band playing classical and popular music. These occasions were very popular and you would hire a deck chair from the wooden shed by the river and sit and enjoy the music. It was not always like this, as when the bandstand was first erected only the more affluent of the town enjoyed the gardens, which in the early days were not open to the public, and a band played every morning from eight until nine o'clock.

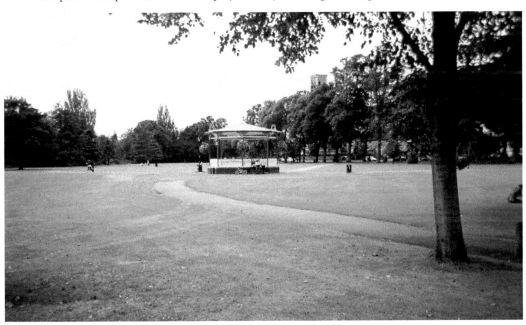

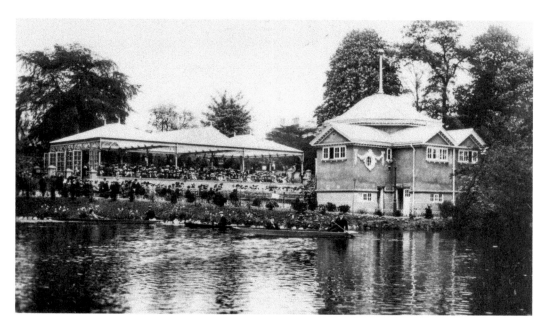

Grand Opening

The photograph above shows the grand opening of the new bandstand in the Jephson Gardens on 27 May 1909, and the view was taken across the River Leam. Alderman A. Holt and Mr Naylor of Harrington House (the present site of the Spa Centre) offered the town a glass auditorium and shelter. The gift was graciously accepted on 27 May 1909, when the official opening of the bandstand and pavilion took place.

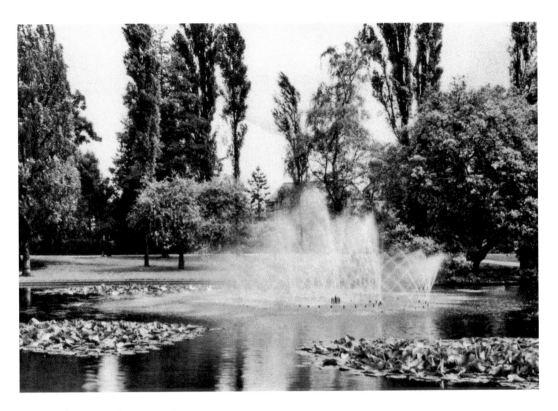

Jephson Garden Fountains

The Jephson Gardens has two fountains that are replicas of those found at Hampton Court. The original fountain was installed in 1925 and an identical one was installed at the other end of the lake in 1926. Both fountains have underwater floodlights thanks to the generosity of Alderman A. Holt, who donated money towards the cost.

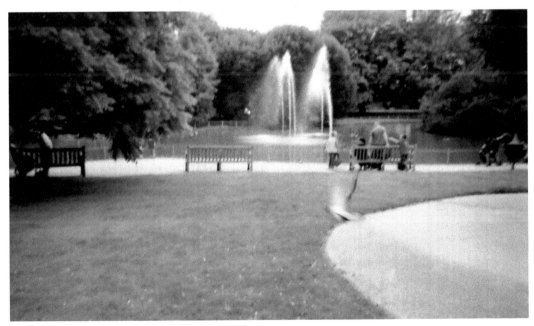

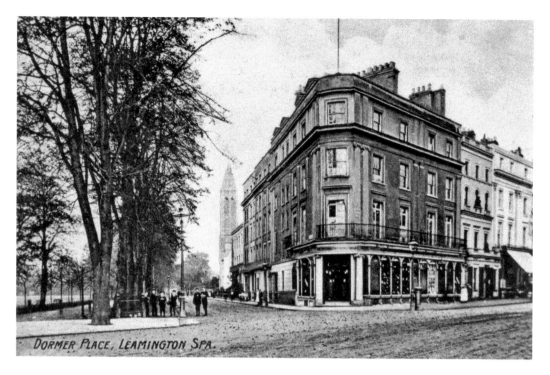

DORMER PLACE, LEAMINGTON SPA.

Dormer Place

The impressive building in the centre of this photograph stands on the corner where Dormer Place meets up with the Parade and was the premises of a National Tailoring Company who ran a very upmarket tailor's. After the tailor's business ceased, the premises became a branch of the National Westminster Bank before converting to its present use as a pizza restaurant. It you walk down Dormer Place towards St Peter's church, seen in the photograph, you will see a plaque reading '5-7 Dormer Place completed 3rd June 1977. This building occupies the site of two former town houses built circa 1840 and destroyed by a single high explosive bomb dropped by an enemy aircraft on the evening of 14th November 1940'. This was the night of the famous Coventry Blitz.

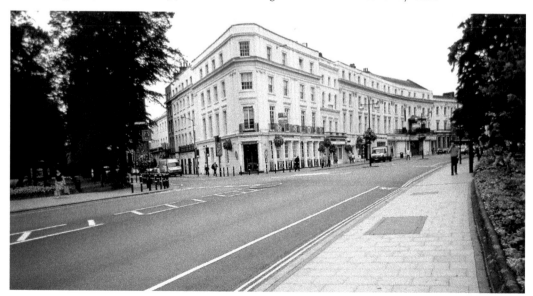

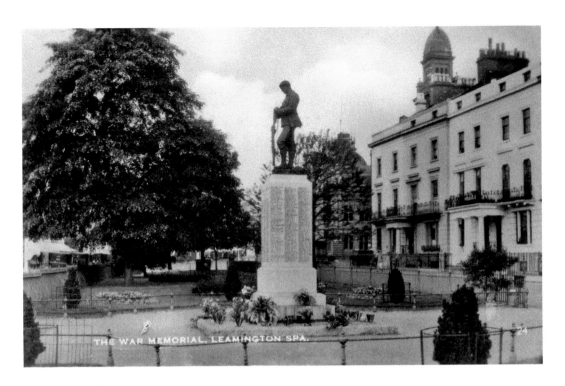

Euston Place

No. 3 Euston Place was the site of the Lansdowne Hotel, which in 1900 was run by Mr and Miss Eggington and can be seen on the right-hand side of Euston Place. The war memorial stands on the gardens in front of the terrace and a plaque on the memorial reads 'To our fallen heroes 1914-1918, 1939-1945, Korean War 1950-1953 and the Falklands Campaign 1982. Listed are the names of those who died'. The memorial statue still stands in Euston Place and forms the focal point of the town's memorial parades.

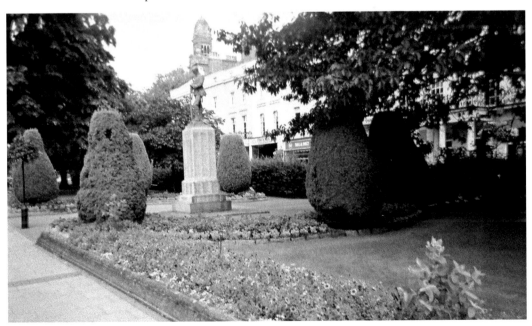

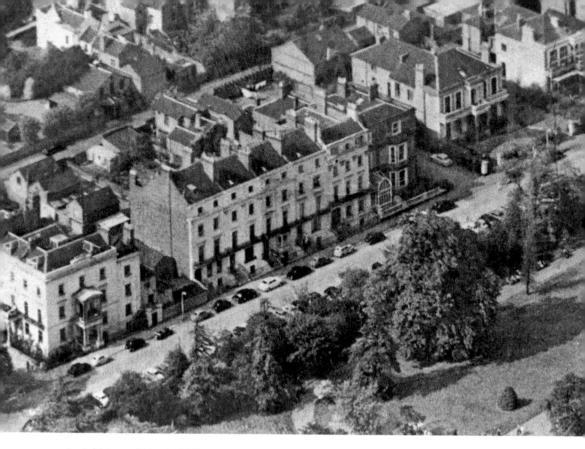

Aerial View of Newbold Terrace

The Jephson Gardens were originally named the Newbold Pleasure Gardens and were laid out around 1834 by Edward Willes' agent, J. G. Jackson, as a commercial enterprise. When the gardens were first open Newbold Terrace was not complete; as late as 1839 it only had a few houses at either end of the terrace with large areas unoccupied and up for sale. I like this view as it shows Newbold Terrace before the tax office and magistrates' court were built there. Currently the magistrates' court is in the process of being completely rebuilt and enlarged.

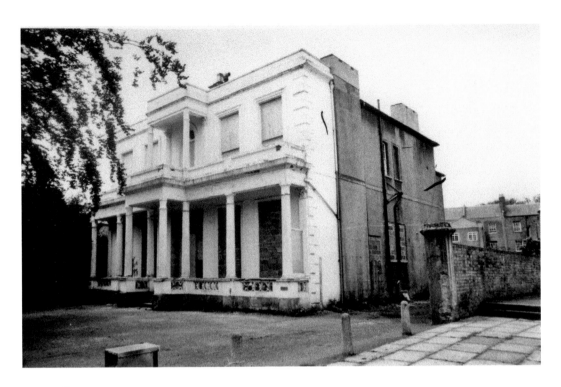

Villa Rossmore

Seen here looking very sorry for itself, the Villa Rossmore in Newbold Terrace started life in 1873 when it was home to Mrs Vicars. After a succession of owners Rossmore was to become an old people's home from 1950 until 1972, in the hands of an old people's welfare society. More recently, from September 1975, Rossmore was used as a reception centre for Ugandan Asian refugees. A decision to demolish the house was taken in 1980, when the building had gone into dreadful decay. After the demolition a modern office complex was erected.

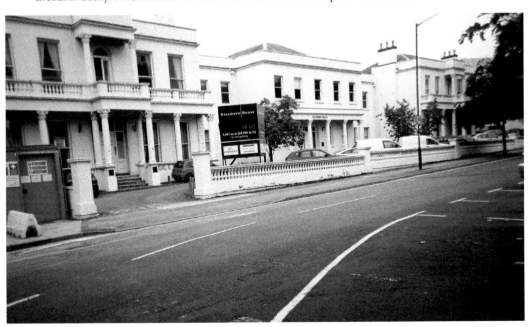

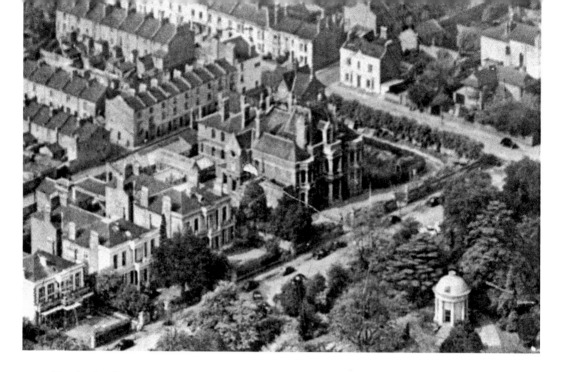

Harrington House

Designed by Edward Welby Pugin, the son of the more famous A. Welby Pugin, this aerial view of Harrington House, built for the owner, Mr Harrington, is a fine example of the outstanding Victorian buildings found in the town at this time. Alas, it met its demise in 1970, when the building was demolished and the town's Spa Centre was built on the site. This was opened in 1972.

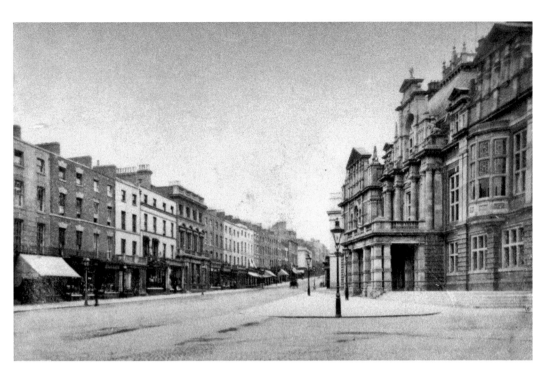

Queen Victoria
This lovely old postcard shows a very different scene from the one below and was taken prior to the erection of Queen Victoria's statue in 1902.

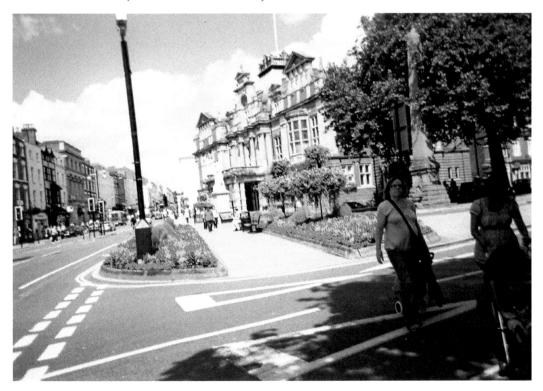

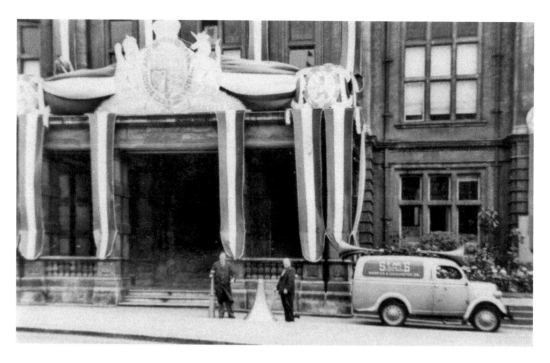

Town Hall Entrance

Decorated for the return of Randolph Turpin after his success in the boxing ring in 1951, when he beat Sugar Ray Robinson for the World Middle Weight title, the two men posed outside the steps to the Leamington Town Hall are George Ivens and Eddie Sims. Although the town hall has changed very little over the years, the entrance has had to comply with the disabled entrance and safety laws currently in place.

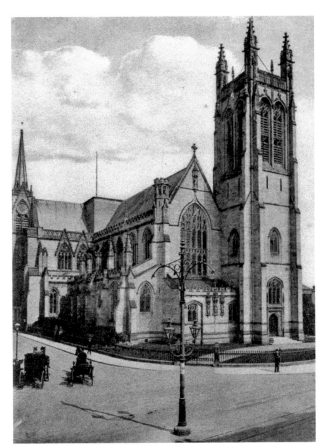

Looking South Down the Parade
In 1808 the first houses of the new town were erected on the corner of Regent Street and the Parade, these were followed in 1810 by twenty terraced houses running southwards from the site of Woodwards. Here we are looking south towards the parish church. On the right are the Pump Rooms.

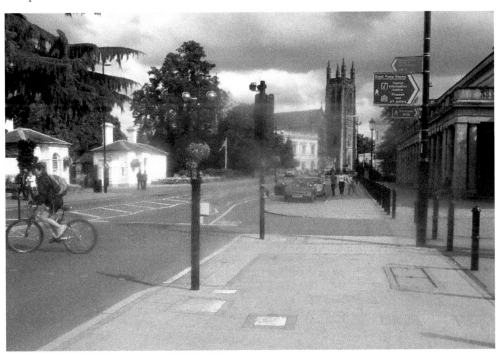

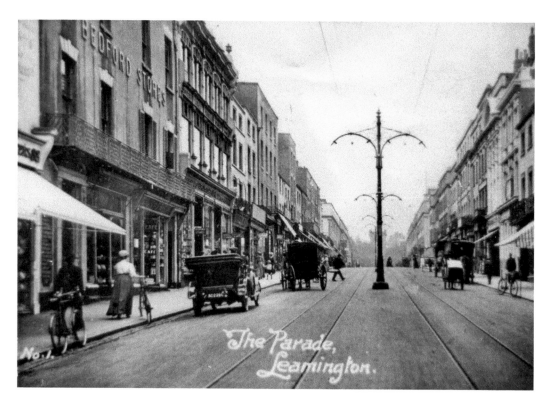

The Upper Parade

The Upper Parade, taken in the late 1920s. On the left you can read 'Bedford Stores'. From 1874 the shop was known as Burgis and Colbourne after two of the town's tradesmen amalgamated their businesses and opened a shop in Bedford Street. The business was so successful that they extended their Bedford Street premises onto the Parade.

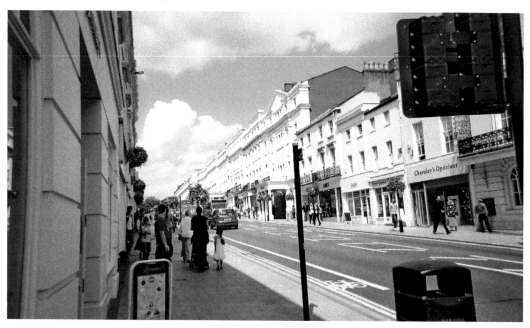

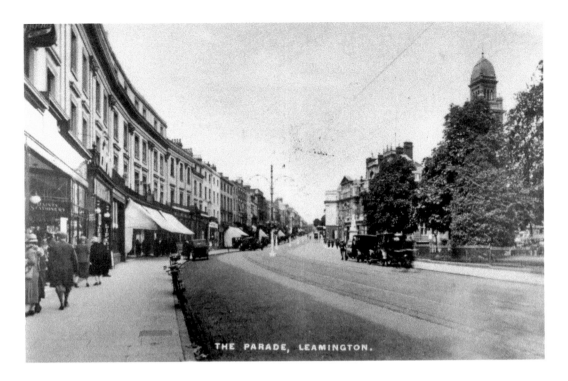

THE PARADE, LEAMINGTON.

Looking up the Parade

This photograph was taken at the end of Regent Grove and Hamilton Terrace and shows the Parade travelling up north from the River Leam. The town hall is on the right.

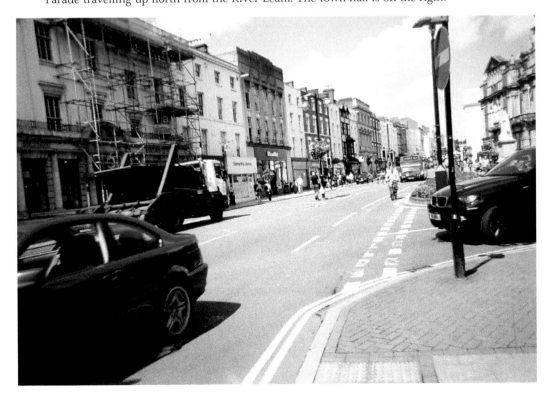

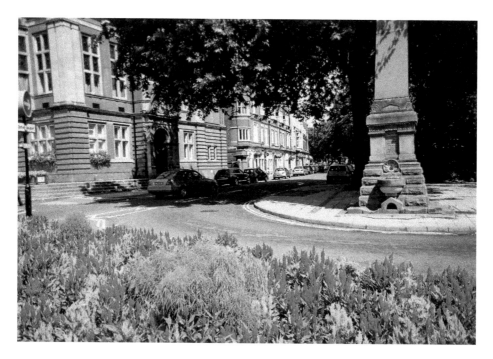

Henry Bright

The Henry Bright Obelisk, seen on the right of this photograph, was erected in 1880 and stands on the Parade at the end of Holly Walk. It was erected in recognition of the great work of Henry Bright on fresh water; until this the town had relied upon the River Leam to supply its water. Although looking a little worn, the obelisk still stands proudly where it was erected. On the left is the town hall, with Queen Victoria on her plinth standing in front of it. On the left just besides the town hall is the Denby Buildings. On the east end of the block is a tablet, which reads '1885'.

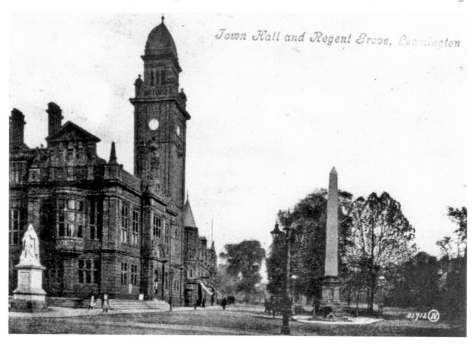

Town Hall and Regent Grove, Leamington

Hamilton Terrace

An unusually quiet picture of Hamilton Terrace can be seen below, taken before the motorcar, parking places, public toilets and the taxi rank.

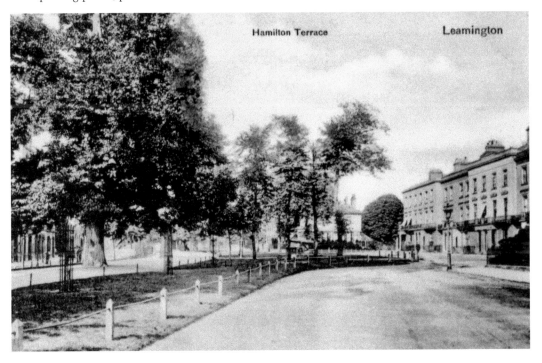

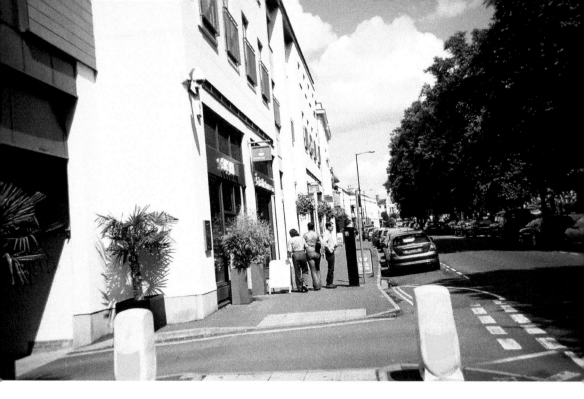

The Theatre Royal

Seen on the right of the photograph, the Theatre Royal is the large building in the centre of the picture. Standing in Holly Walk, the building was built by Mr John Fell for a local Syndicate and cost in the region of £10,000 when new. Like many other lovely old buildings in the town it has undergone change over the years.

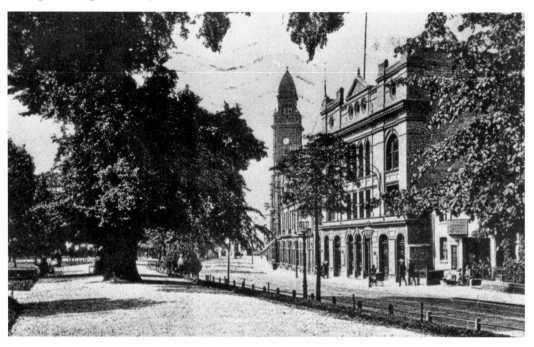

P. H. Woodward and Co. Ltd

Negotiations for the purchase of the business from Mr E. T. Gamage commenced on 3 March 1908. It was to be six years later, in 1914, due to increased business, that a large area of floor space was added to the existing premises. The First World War was to bring to a stop any further plans for expansion. However, despite this setback the business was to expand into the furnishing field not long after the war finished, so that the adjoining premises in Regent Street were acquired in 1927, and the space was put to good use. In 1933, due to ill health, Mr P. H. Woodward was compelled to retire from the managing directorship of the company and Mr Oswald Davidson took over. Mr Woodward remained on the board until his death in 1944. The building is now under the ownership of the Island River group of companies, after undergoing intensive refurbishment.

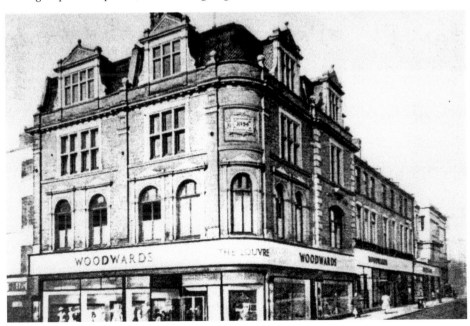

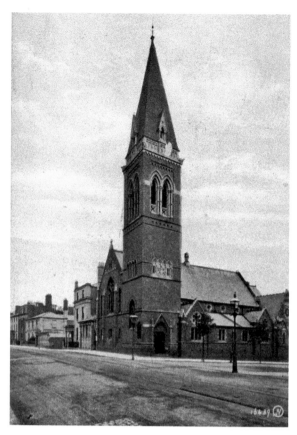

St Alban's Church

This was originally called the Church of St Michael and All Angels, and it was built by John Fell in 1864 for less than £2,000. Dr Nicholson then purchased the church after he had left Christchurch in 1880 for the princely sum of £5,600, and not long after his purchase he changed its name to St Alban's church. The building stood at the junction of Warwick Street and Portland Street. It was known locally as the mouldy cheese steeple because the church had a green copper spire. Alas, the church was demolished in 1968. A block of offices known as St Alban's House now stands on the site.

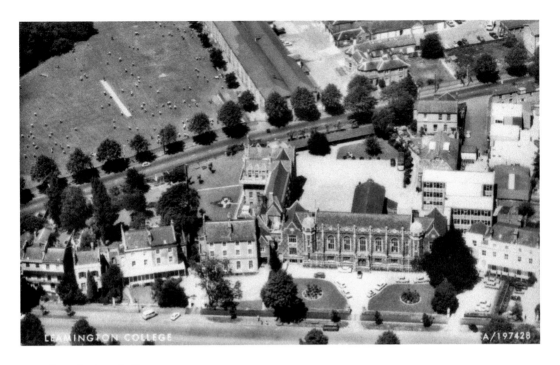

Leamington College

The original Leamington College was built by David Squirhill in Binswood Avenue in 1847-48 meeting the demand for a school for the upper classes and was known as the Warwickshire Proprietary College. Due to the poor reputation of the upper class schools, which were renowned for cruelty and bullying, the pupils who received their education from the confines of their homes were considered luckier in comparison to the alternative! In 1880 there were a lot more schools built and attendance became compulsory. After many changes the school is now boarded up and Leamington has lost another of its gems.

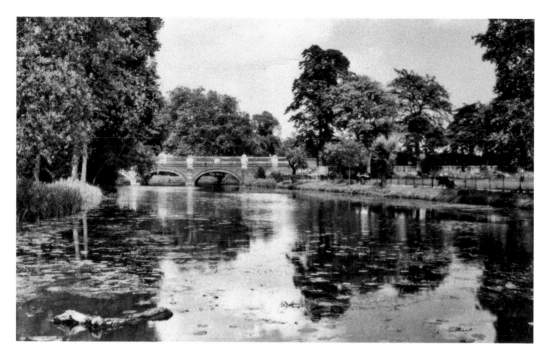

Willes Road Bridge

Built in 1827 and improved in 1876, the Willes Road Bridge has a stone tablet in the centre of the West Parapet which reads, 'This tablet was placed here by the inhabitants of Leamington to record the munificence of Edward Willes Esq., of Newbold Comyn, to whom the town is indebted for the site of the adjoining public gardens, (Jephson) for the bridge and road and many other valuable gifts.' The title of the bridge was changed from its original name, The Newbold, to Willes Bridge, and was crowned on each side by a falcon, the badge of the house of Willes.

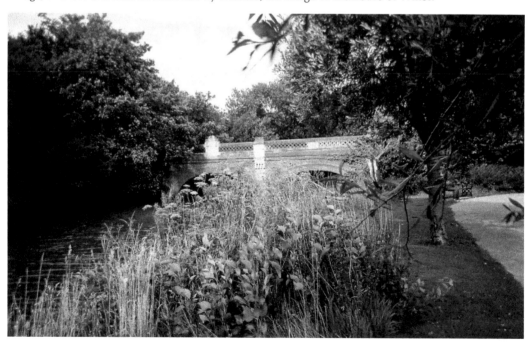

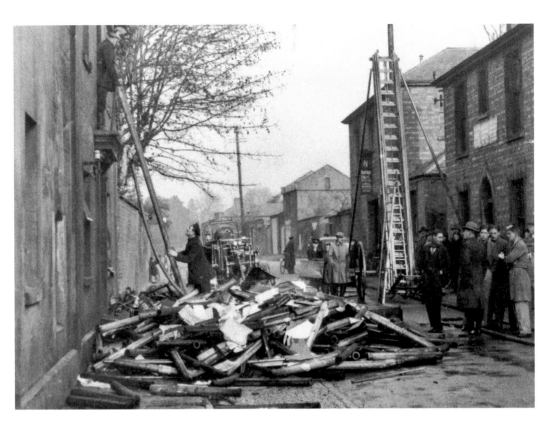

Cross Street
Bomb damage during the Second World War brought the town's fire service into action.

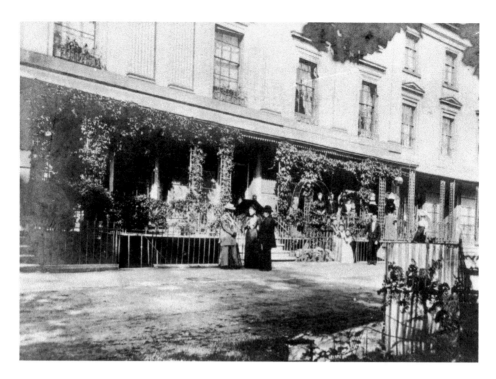

Lansdowne Crescent

Leamington was renowned for its high-class hotels, mainly come about after the discovery of the saline springs and the wealth of the people who visited the town to take the waters. La Plaisance Private Hotel, which occupied 41-43 Lansdowne Crescent, was a fine example of the high-class private hotels to be found in the town around 1901. The lady in residence at this establishment was Miss Profit-White. Among the residents listed in Spennell's almanac as residing there in 1902 were Mr Tom Profit-White, Miss Seville and Ms Tomlinson.

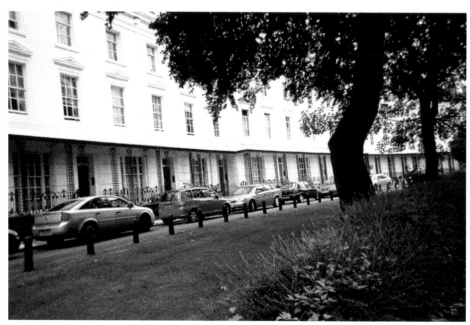

Lansdowne Circus
Like all royal towns of note, Leamington also has a circus, Lansdowne Circus, which is famous for its association with Nathaniel Hawthorne who lived at what he affectionately referred to as his 'little nest', No. 10. The land for the circus was given by Squire Willes in 1843 on a 2,000-year lease.

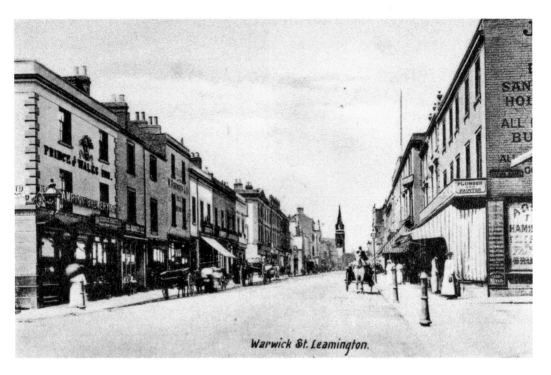

Warwick St. Leamington.

The Prince of Wales

This delightful photograph recaptures the tranquillity of 1910, when there were horse-drawn carriages and few pedestrians. On the left you can see the Prince of Wales Inn. Things have changed slightly, as you can see from the bottom photograph you literally take your life in your hands when you cross the street nowadays and the pavements are always heaving with pedestrians.

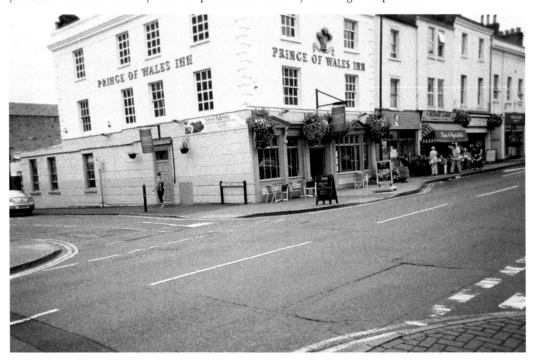

Clarendon Avenue West

Taken at the turn of the twentieth century you can clearly see in this photograph the rough road surfaces of the horse-drawn vehicles. Edgar Ringers business premises are in the large house on the corner of Beauchamp Square and overlooked the beautiful Beauchamp Gardens.

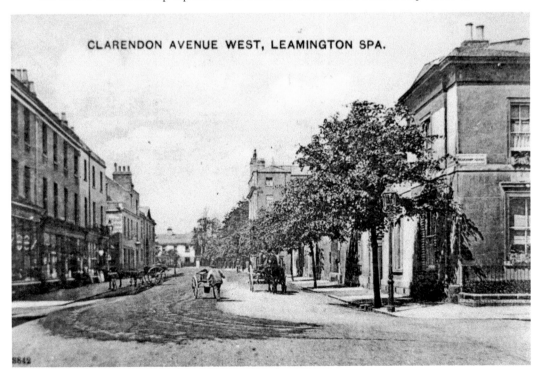

CLARENDON AVENUE WEST, LEAMINGTON SPA.

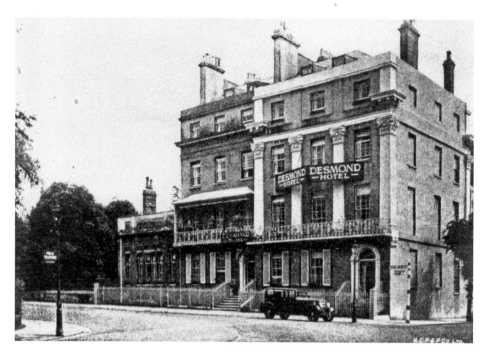

Desmond Hotel

Another example of local builders' inclinations to convert the town's beautiful old buildings into apartments is the former Desmond Hotel. In the early 1930s the proprietor was Mrs Gower and the hotel, which stood on the corner of Kenilworth Road and Clarendon Avenue, boasted forty-two bedrooms. It was listed as a private first-class hotel.

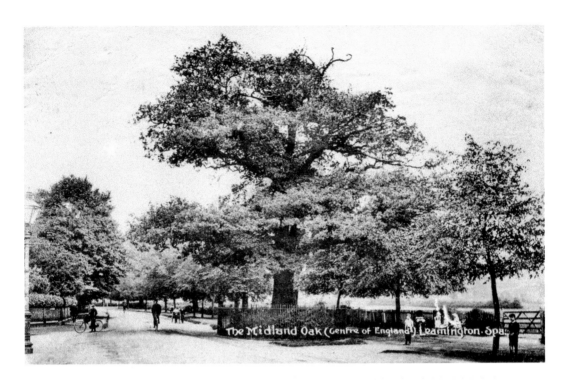

The Midland Oak (Centre of England) Leamington Spa.

Midland Oak

The oak tree, or 'round tree' as it has been known for many years, is said to mark the centre of England and it is thought to be one of the Gospel Oaks. It stood at the junction of Lillington Avenue and Lillington Road, until through old age it was felled in 1960. It has since been replaced by a sapling.

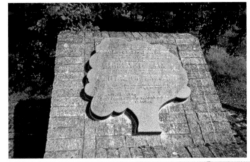

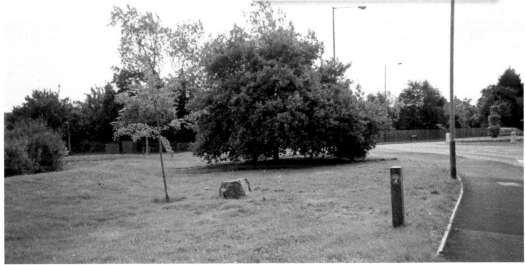

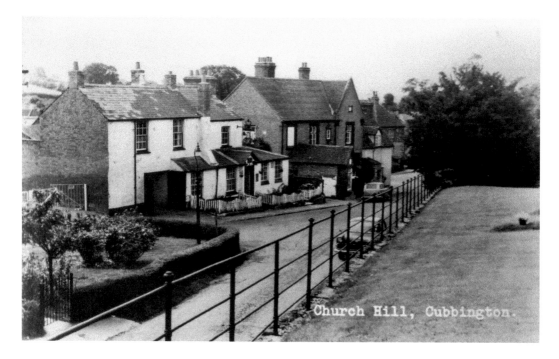

Church Hill, Cubbington

A view of Church Hill, Cubbington. There were four public houses in the village at this time and each public house brewed its own beer. The aroma would have been lovely when the pig keepers wheeled their barrow load of grains down the street and the hot steaming grains came from the vats. Each of these pubs would have had a skittle alley and nine pin bowling green. Mr Lambert was the landlord of the Queens Head. Near the pub was a house that had been erected for a school, but the left-hand side of the building was used as a lock up.

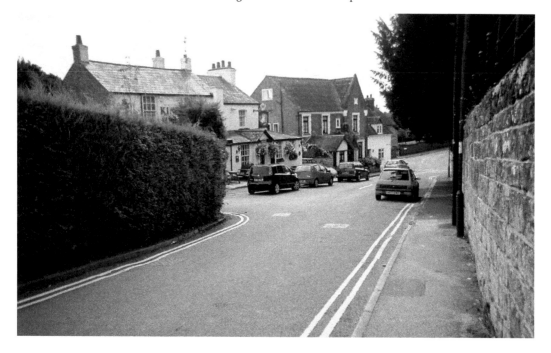

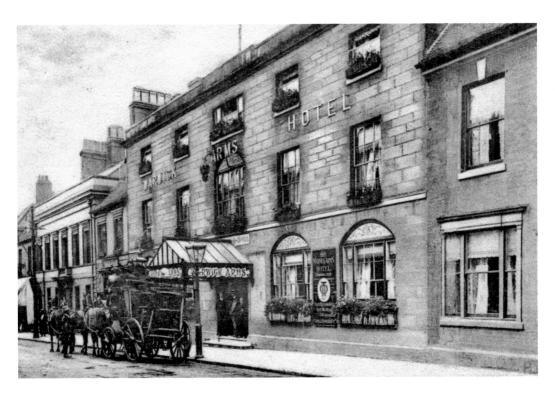

Warwick Arms Hotel

The Warwick and Leamington horse-drawn tram route was opened in 1881 and was superseded by electric trams in 1905. The Warwick terminus for the trams was outside the Warwick Arms Hotel. If you travel down the road to the right of the photograph you will come upon the west gate into the town.

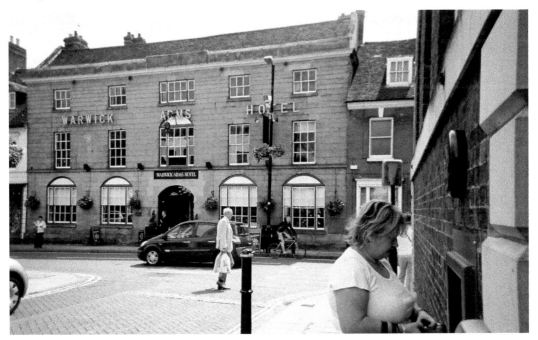

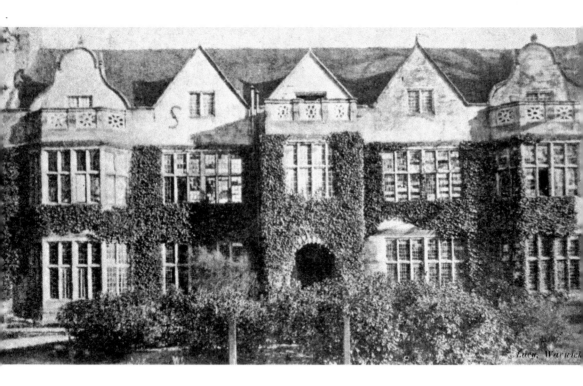

St John's House

Originally the Hospital of St John the Baptist, St John's House was founded in the reign of Henry II. Intended for the use of the homeless, poor and travelling strangers, the building consisted of a gatehouse, chapel and two houses. It was to change its use several times before being purchased by the Earl of Warwick in 1780, where it remained in the family until 1960. Between 1791 and 1881 it was a school, and in 1924 it became a military record and pay office. It is currently a branch of the County Museum and houses memorabilia of the Warwickshire Regiment.

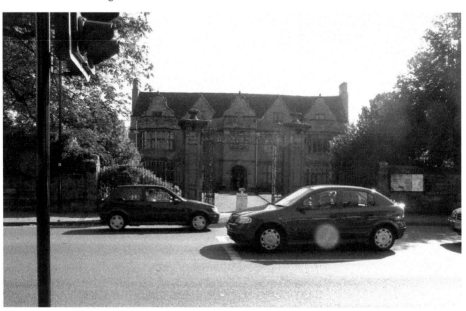

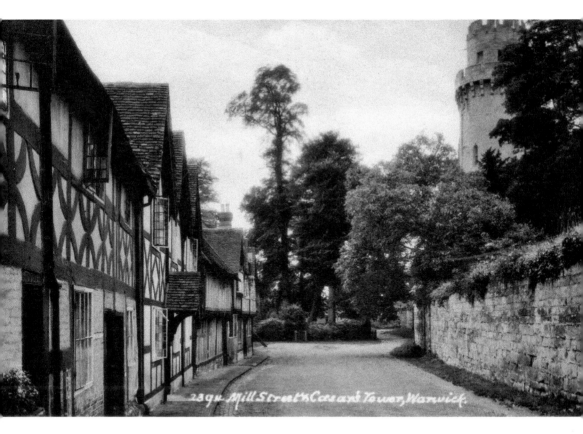

Old Warwick

A lovely glimpse of old Warwick from a postcard view of around 1912, part of the castle wall can be seen on the right. Taken in Mill Street, Caesar's Tower is clearly visible.

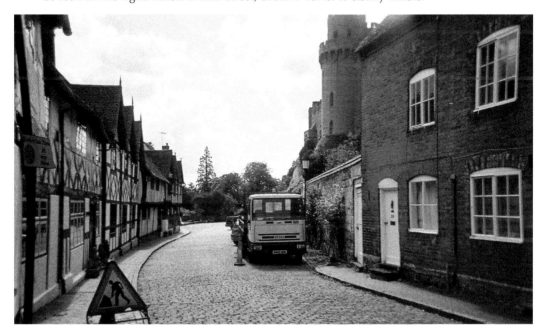

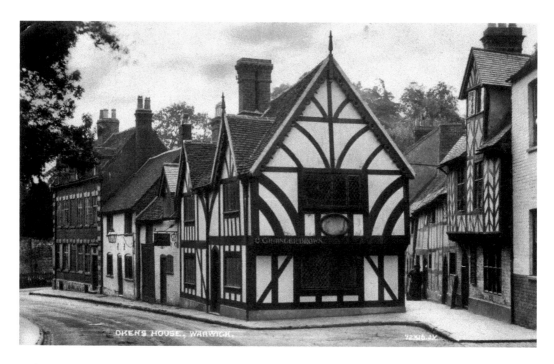

Oakens House

The house dates back to the sixteenth century, and from 1885 until 1909 W. Clarke, a baker, occupied the premises. Much later it was taken over by Grainger Brown Antiques and became a successful doll museum. Currently it is run as tea rooms.

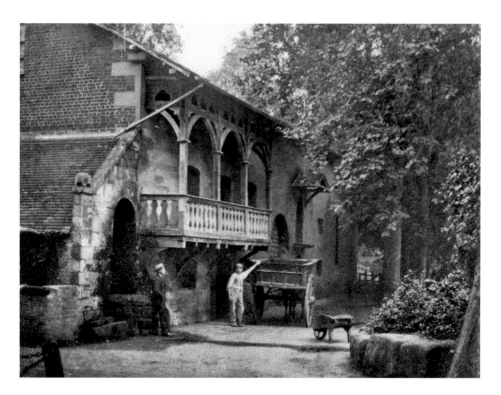

Guy's Cliffe Mill

There has been a mill at Guy's Cliffe since the twelfth century, although the present building is chiefly eighteenth century. In the photograph Guy's Cliffe Mill is seen as it looked in the 1880s, but is no more a working mill. Alas, the mill and adjacent mill house are now joined together, and it is now a successful bar and restaurant.

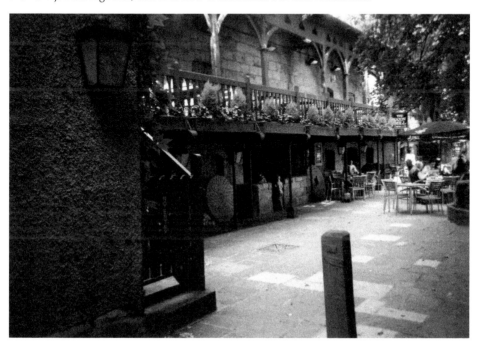

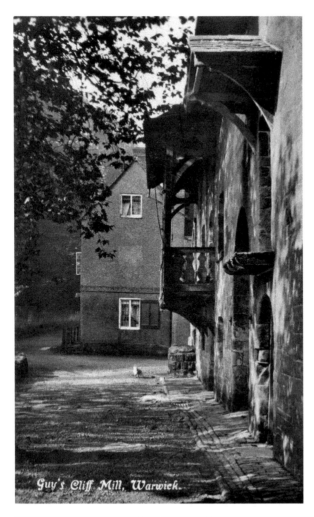

Guy's Cliff Mill, Warwick.

Another View of Guy's Cliffe

Here we see two contrasting pictures of Guy's Cliffe Mill, one of the mill as it was in the 1880s and the other of the front of the building as it looks today. It is now known as the Saxon Mill and is a very successful bar and restaurant. Standing on the River Avon about a mile and a half north-east of Warwick it is said that there has been a mill at Guy's Cliffe since the twelfth century. It is an interesting building, as the actual mill and adjacent Mill House were separate buildings at one time but are now joined together.

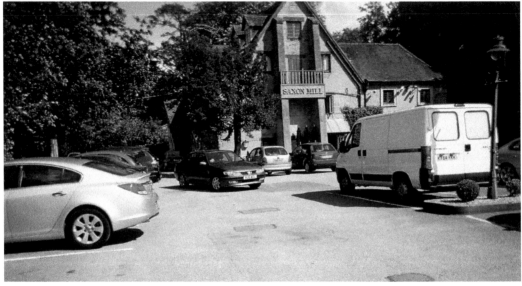

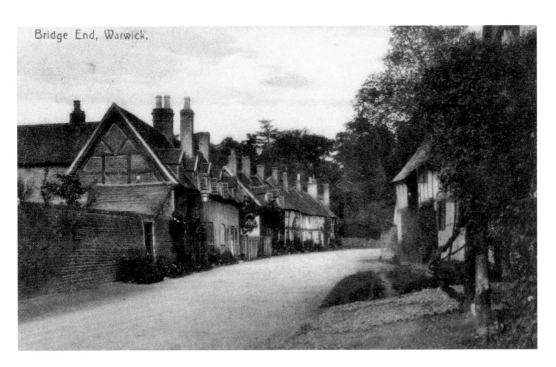

Bridge End, Warwick.

Bridge End

Bridge End would have been situated at the end of the old bridge that connected the Bridge End area of Warwick with the castle end of Mill Street. At the end of the eighteenth century Lord Brooke and Warwick Corporation donated £4,000 to build a new bridge further up stream. If you look towards the castle from the new bridge you can still see parts of the old bridge, which was considerably nearer the castle.

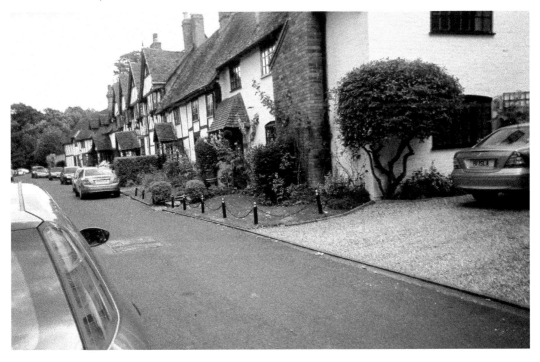

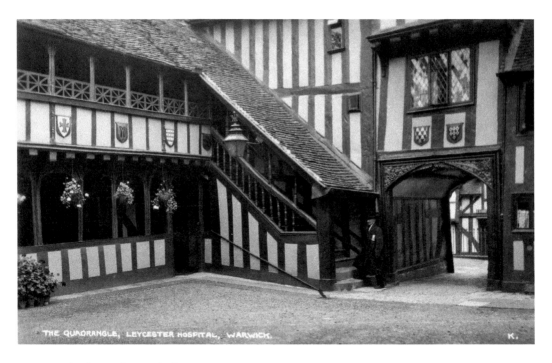

THE QUADRANGLE, LEYCESTER HOSPITAL, WARWICK.

Lord Leicester's Hospital

In the mid-1600s ancient almshouses were frequently requisitioned for military use. Lord Leicester's was no exception, and the hospital's life was disrupted and its revenue disappeared as parliamentary troops took over the chapel and constructed the town's fortification through its grounds. This was long ago, and although the house looks very much as it always has done it has now become a popular tourist attraction. Behind the flowers in the bottom photograph is a very quaint tearoom, with beamed ceiling and a lovely huge fireplace, where Tina and Neville Dorn, ably assisted by Kath Batchelor, help to make a visit to Lord Leicester Hospital one to remember.

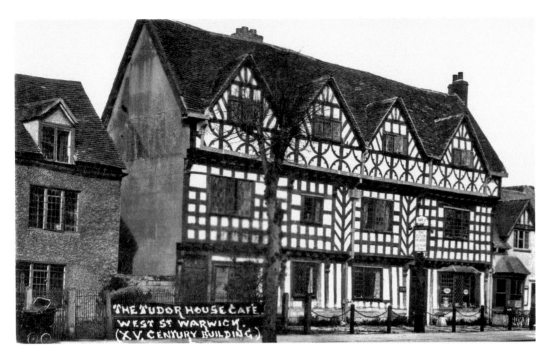

Tudor House

Another one of Warwick's beautiful old buildings, the Tudor House in West Street has changed very little over the years.

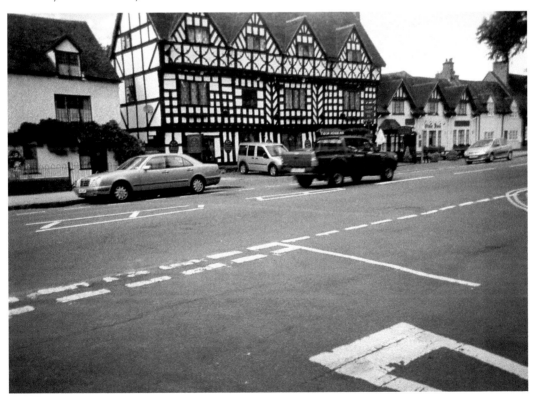

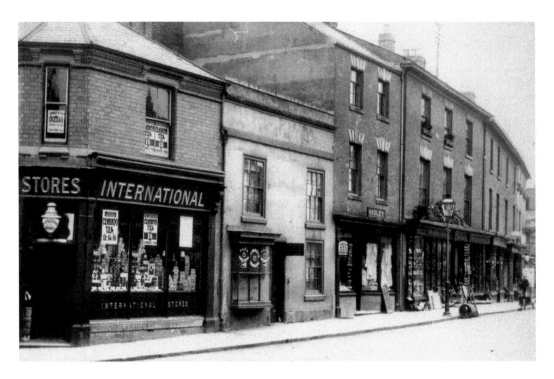

Market Place

The International Stores are no more and the premises now houses an optician's. The shop next door sells bridal wear and there is also a Help the Aged charity shop before coming to Wylies hardware store. Here you can step back in time; if memory serves me right, it hasn't changed much since I was a child. If you walk down the alley besides Wylies you will find the Victorian café on the left run by sisters Vickie and Kate along with their mum.

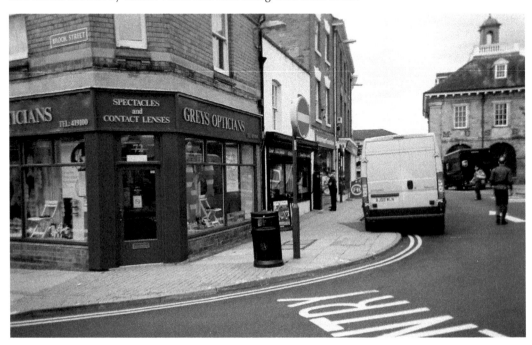

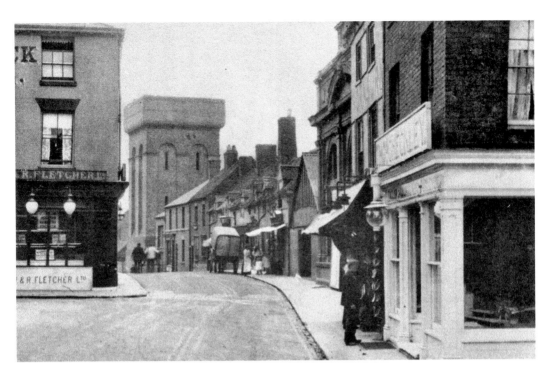

Market Street Warwick
Here we see the Water Tower, *c.* 1910, which was demolished in 1923. Fletchers Stores can be seen on the left, and set back slightly on the right of the photograph behind the shop window blind is the Cornmarket.

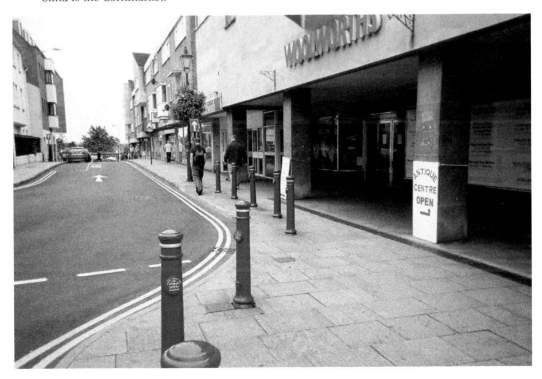

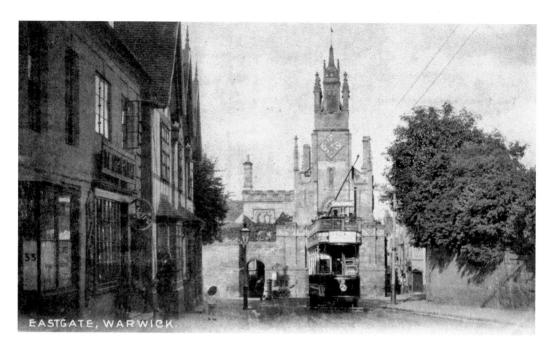

Warwick East Gate

The east gate is one of three main gates into the town, the others being the north and west side. Probably constructed in the fifteenth century, it has the Chapel of St Peter built over it. On the left is the town's famous Porridge Pot, which was a popular high-class café when this postcard view was taken, probably in the 1930s. The east gate now forms part of the Kings High School for Girls and the Porridge Pot has now become a pizza parlour.

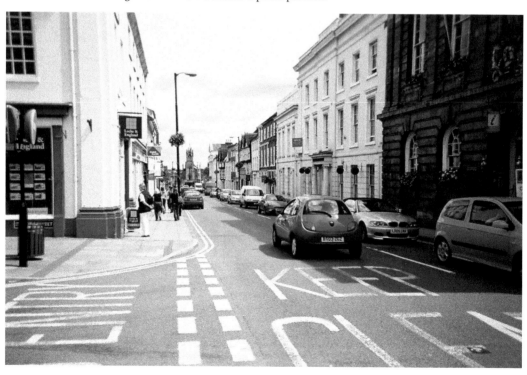

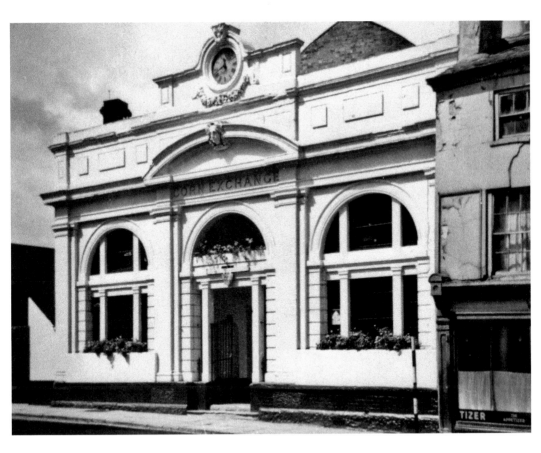

The Old Corn Exchange

Before the building was demolished and rebuilt it was Woolworth's. The building beside the Corn Exchange on the right was a fish and chip shop.

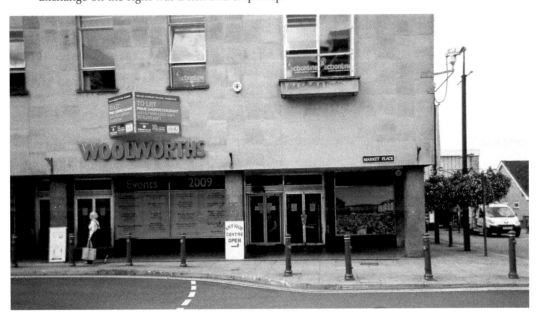

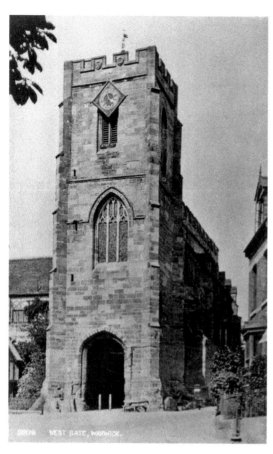

West Gate
These photographs show the early fifteenth-century tower of St James' chapel that stands above the west gate into the town.

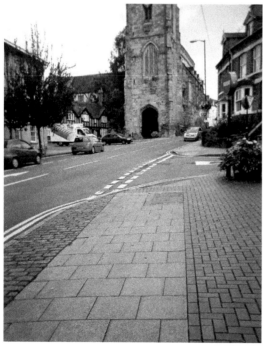